Writers

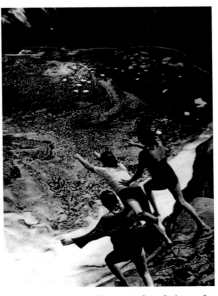

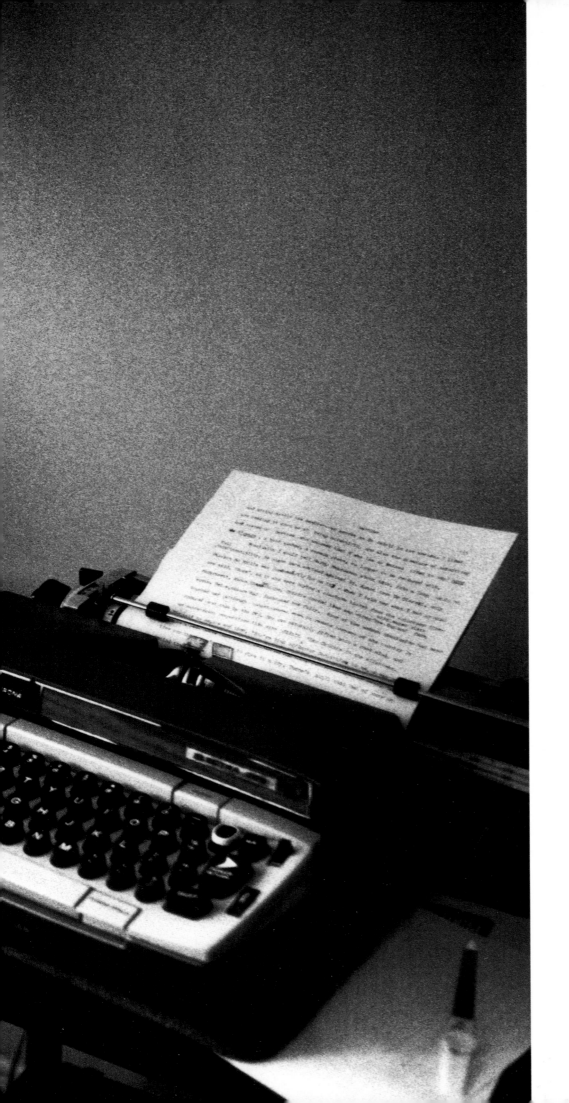

Writers

photographs by
Sally Soames

preface by
Norman Mailer

Published by André Deutsch

First published in Great Britain in 1995 by
André Deutsch Limited
106 Great Russell Street
London WC1B 3LJ

Compiled and edited by Sally Soames

HB: ISBN 0 233 98945 5
PB: ISBN 0 233 98905 6

Cataloguing-in-Publication data available
for this title from the British Library

Book designed by Atelier
Repro by Master Image, Singapore
Printed and bound in Great Britain
by BPC Hazell Books Ltd
A member of The British Printing Company Ltd

For my Mother and my Father and my son

Introduction

For twenty-five years at The Sunday Times of London I have photographed people of every description. My particular focus, however, has been on writers. How can I, photographing their faces, tell something of their ability to create, influence, teach, weave magic?

I have tried my best.

I would like to thank them all; each has enriched my work.

In particular, I am grateful to the writers who appear in this book because they have added words – of their own or by others – to accompany their photographs.

Sally Soames
July 1994

List of plates

The dates refer to the year
that each picture was taken.

The title page shows
Saul Bellow's desk in Chicago, 1992.
The back cover image shows
Norman Mailer.

Preface

On the day that Sally Soames took the photograph of this author that you see in this book, the subject was feeling flat and dispirited. He had agreed to do more publicity that day than he had any belly for, and in consequence, the session with Ms Soames came at the end of a long afternoon of interviews that had left him with the uneasy recognition that once again he had said too much, and would therefore be misquoted and over-condensed and would sound like a representative of that famous law firm which represents media fools – Garish and Gauche. I was obviously in a bad mood, and now just when I wanted to go home, I had a camera session with an English photographer – one Sally Soames.

It is, however, Sally Soames' first virtue as a photographer that she is sensitive. So few are any longer. They are privy to the ugly secret. He who sits for a photographer is less meaningful to the final result than the camera lights that can be brought to bear on him. Light the mother properly and you can turn a sow into a corporate executive.

Sally had promised in advance to use naught but available light. She kept her word. Under the circumstances – my fatigue, and her need to work by a window in a half-dark room – I confess that I am taken with the result. We talked, and she took photographs, and the media-miasma must have passed out of me, for the result is agreeable to me. I look well-possessed of myself, even executive, and not without humor, and that speaks of the photographer's magic, having been none of the three on entering the room.

You will find vastly more exciting photographs of other people in this book, but none, I suspect, who were brought out of one mood and led to another over such a distance. It speaks to the true skill of the photographer. The relation between the eye that commands the lens and the subject is essentially an oppressive and one-sided relation (which is why prominent subjects are so often rude to photographers – they feel they are merely redressing the balance!) It is Sally Soames' gift to take that arid and mutually exploitative encounter, and turn it into the rarest of media transactions – an agreeable ten minutes between two strangers who thereby are left with the simple reminder that fellowship is also a communion natural to us, and so you can even meet it unexpectedly in the course of your hectic way. Three cheers then to Sally. She really believes she will find the light in the eyes of the subject, and, belief being the force that it is, bygodoften she does.

Norman Mailer

...surely

...herself, vir...

...right break

...ordinary, ...

...behaved ...

...matters abr...

...he became,

...t a ment-

woman, sh...

soft chee...

to the no...

tainly uncov...

...on, trying

...utely My one

...at a new

...trous part...

Dr Haggard's Disease

Oh James. Love – adult romantic love –
I have come to believe is an attitude of
passionate devotion to an ideal. Your
mother came to represent for me an ideal.
She came to seem the very embodiment
of grace. Grace: it was manifest in
everything about her, it was the ineffable
breath of being in all she said, and did,
and thought, and felt – her spirit, in
a word, she possessed *grace of spirit* and
was as incapable of vulgarity as I believe
any human being can be. I am a man and
a doctor. The body sickens, it goes wrong,
it stinks, it rots, it dies. This is where my
work is, with the diseases of the flesh.
It has become as essential to me as life
itself that I animate the pitiful spectacle
of sickness and pain with a meaning that
transcends mere mortality. The love I
conceived for your mother gave me the
sole glimpse I have had of the possibility
of such meaning, my one thin thread of
hope: where before there was only the
dark face of nature, with its absolute
imperatives of disease, suffering and
death, now there was grace. The irony
of my life, if not its tragedy, is that I did
not understand this until it was too late;
only then, as I retraced in memory the
vertiginous arc of our affair, and the
desperate, terrible brutality of its ending,
did I properly come to know what it
signified.

The tragedy of my life, then, the failure
to understand the nature of love, until
it was too late.

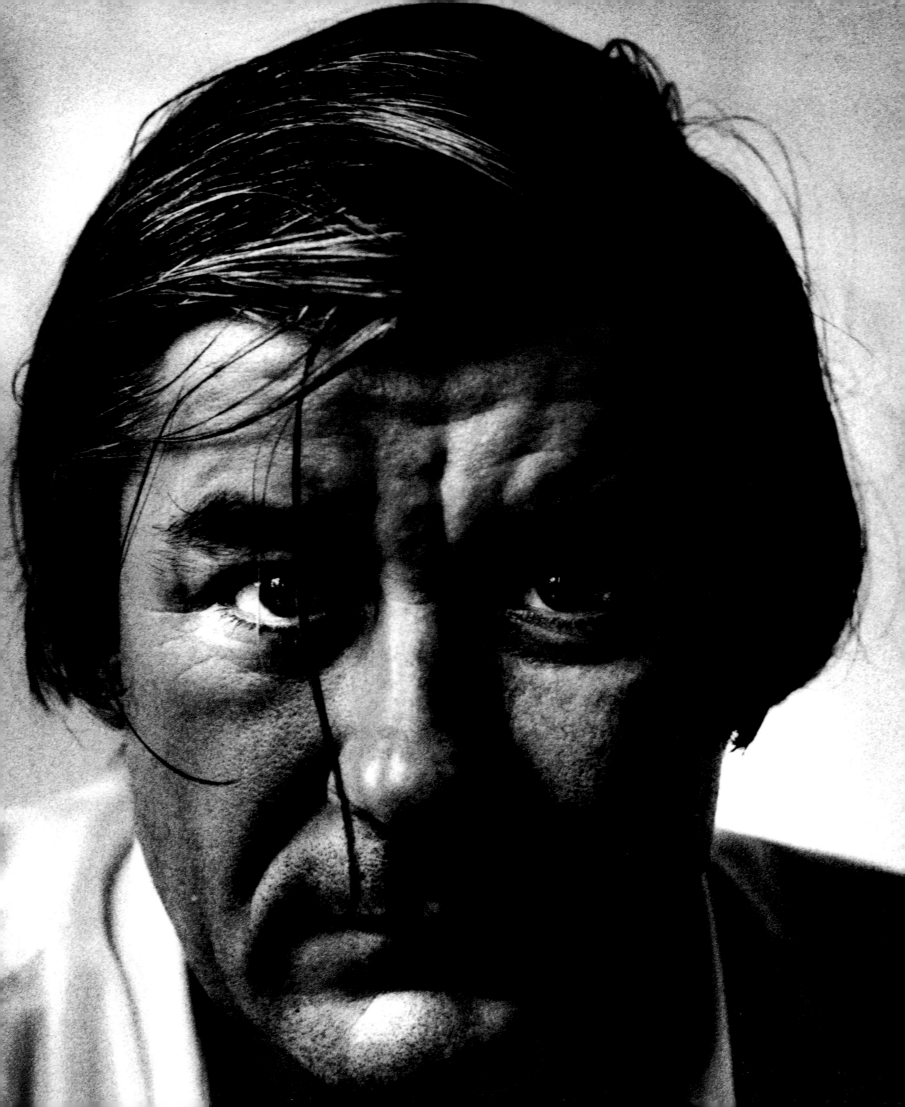

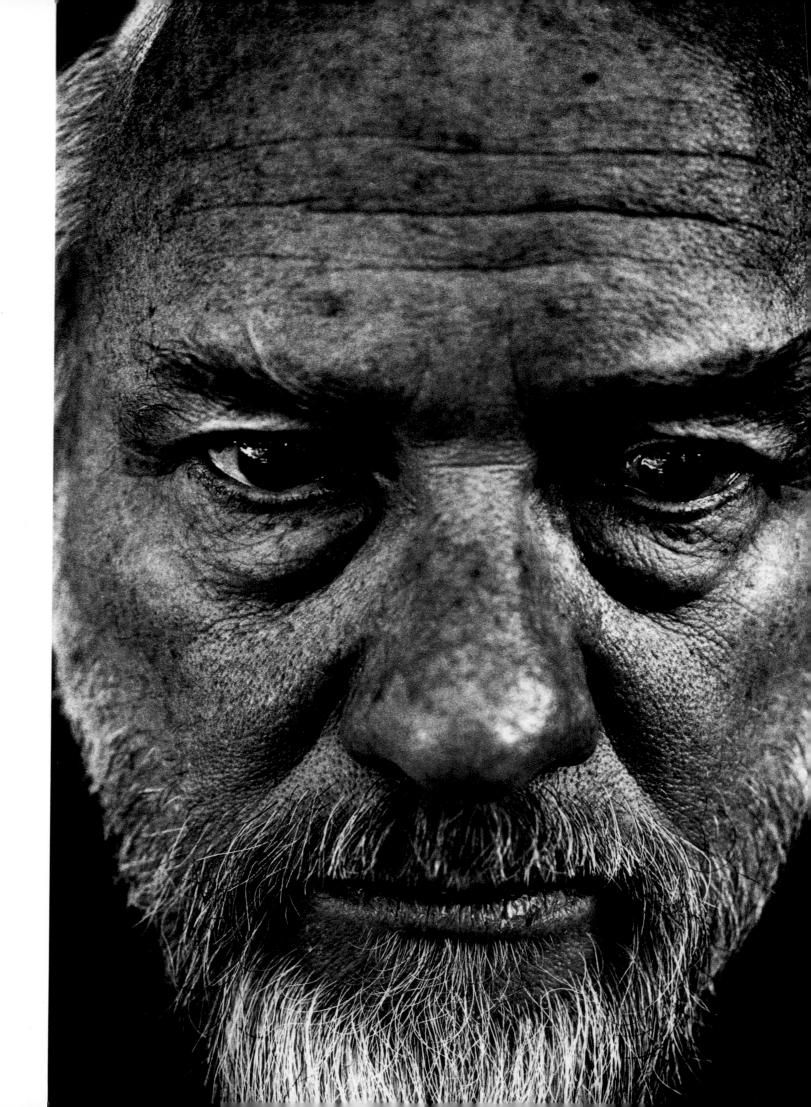

Robert Stone 1992

Outerbridge Reach

By evening the wind was still increasing.
The sea was gathering itself up in towering
masses that rolled from the horizon,
trailing ghostly wands of foam. The sight
of these enormous rollers and their fragile,
attendant spindrift hypnotized Browne.
He had never been out in such a sea before
and never heard such wind. The boat felt as
though she were gliding, airborne. The sky
overhead was prison gray. He understood
that he was about to experience the true
dimensions of the situation in which he
had placed himself.

Doris Lessing 1988

The Subtleties of Mulla Nasrudin
The Sufis, by Idries Shah

The Mulla walked into a shop one day.
The owner came forward to serve him.
'First things first;' said Nasrudin, 'did you
 see me walk into your shop?'
'Of course.'
'Have you ever seen me before?'
'Never in my life.'
'Then how do you know it is *me*?'

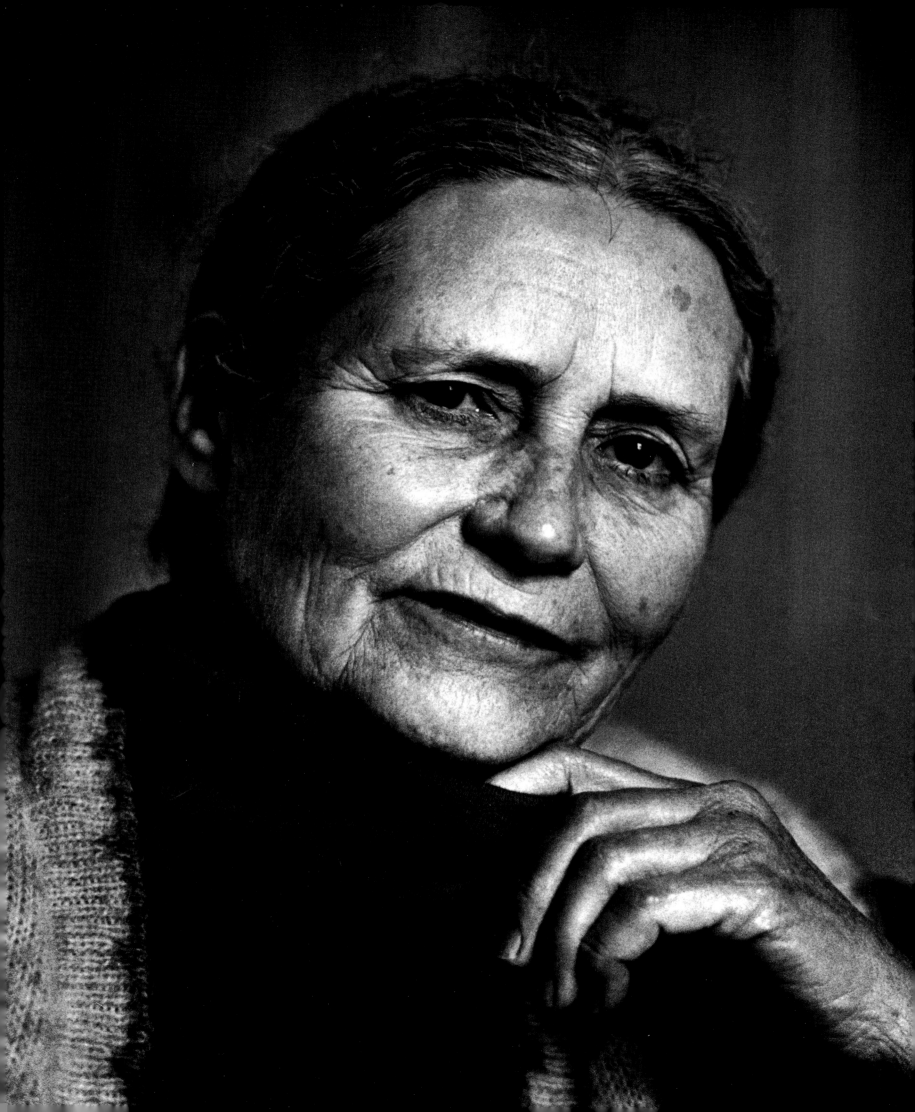

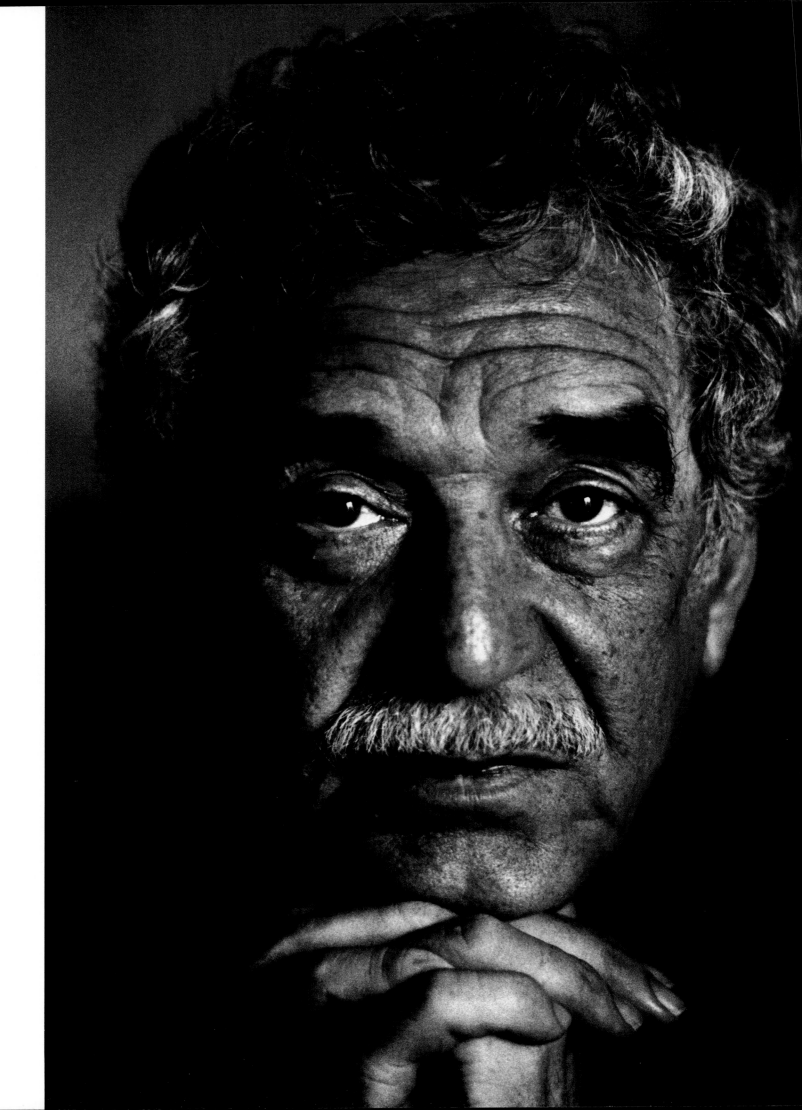

Love in the Time of Cholera

At midnight he put on his Sunday suit and went to stand alone under Fermina Daza's balcony to play the love waltz he had composed for her, which was known only to the two of them and which for three years had been the emblem of their frustrated complicity. He played, murmuring the words, his violin bathed in tears, with an inspiration so intense that with the first measure the dogs on the street and then the dogs all over the city began to howl, but then, little by little, they were quieted by the spell of the music, and the waltz ended in supernatural silence. The balcony did not open, and no one appeared on the street, not even the night watchman, who almost always came running with his oil lamp in an effort to profit in some small way from serenades. The act was an exorcism of relief for Florentino Ariza, for when he put the violin back into its case and walked down the dead streets without looking back, he no longer felt that he was leaving the next morning but that he had gone away many years before with the irrevocable determination never to return.

Paul Theroux 1992

Sunrise with Sea Monsters

I think I am an optimistic person, but that
night, traveling home to my house on the
Cape, I had a dreadfully hollow feeling.
Things had not seemed so black since high
school. *What is going to happen to me?*
I used to think. I had wanted to write.
I did not have the courage to say I was
going to be a writer. A doctor, a teacher,
a forest ranger – it did not seem to matter
what I said, because it would never
happen. I knew only one thing for sure.
It was this: Nothing will happen to me
in Medford – worse, I will fail here. High
school was proof of that. Was my brain
teeming with schemes and fantasies?
I think it was. I had a riotous imagination,
but even that worried me into secrecy,
for I had done nothing, and I certainly had
not used it. Going home now was like going
home from high school, and it provoked
the same reflection: *We are all riding into
the dark, alone.*

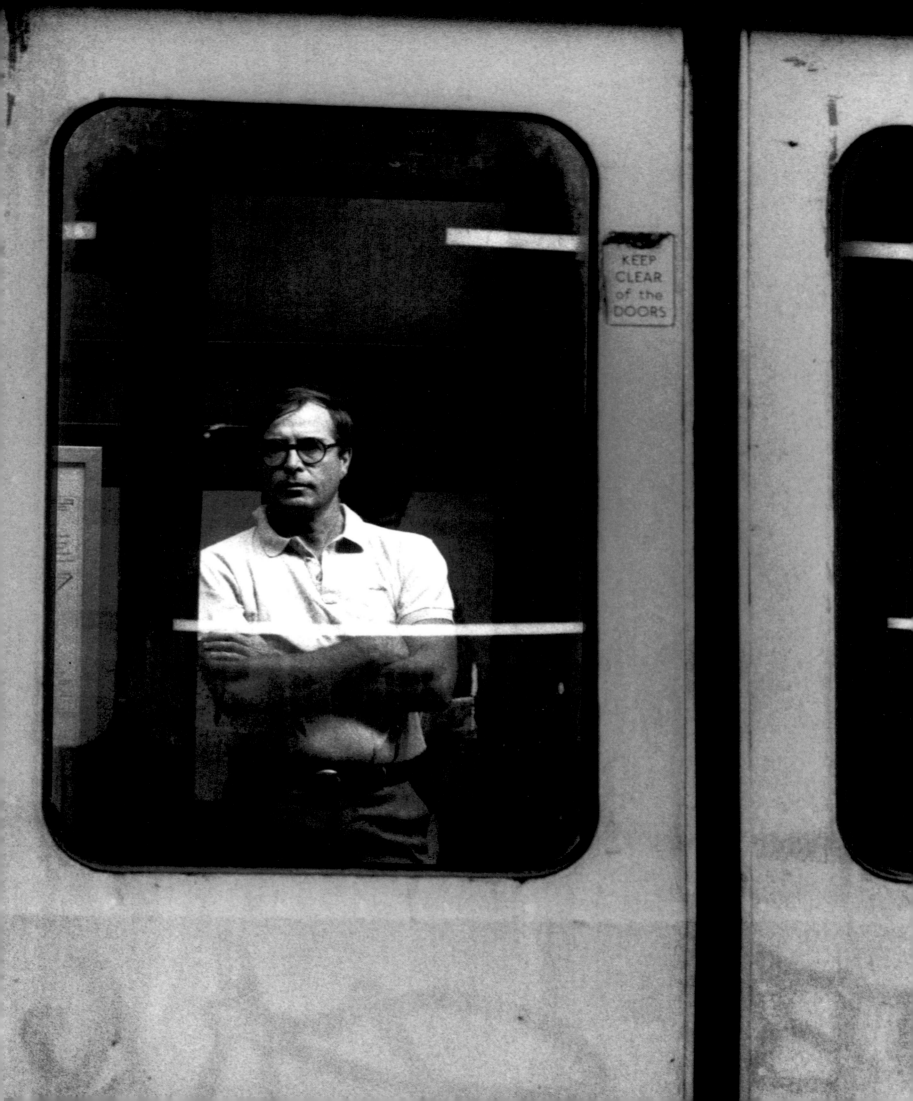

KEEP
CLEAR
of the
DOORS

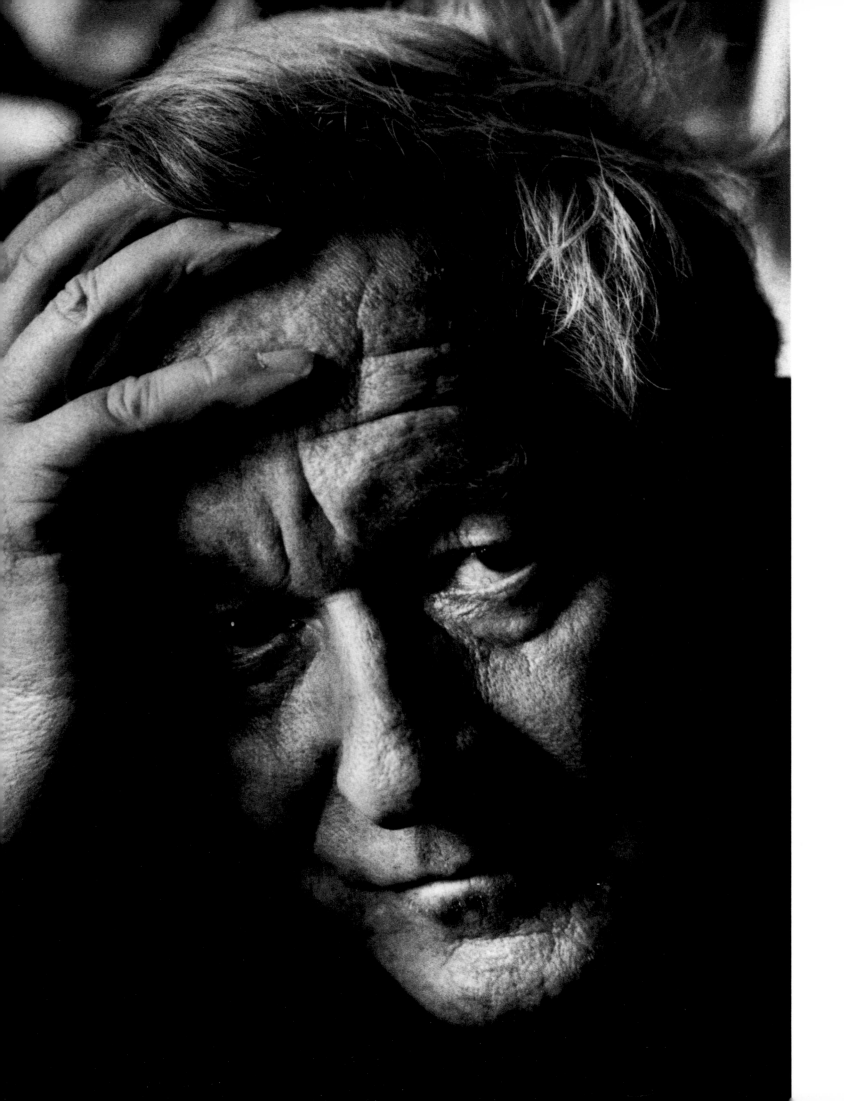

William Styron 1991

Darkness Visible

There were also dreadful, pouncing seizures of anxiety. One bright day on a walk through the woods with my dog, I heard a flock of Canada geese honking high above trees ablaze with foliage; ordinarily a sight and sound that would have exhilarated me, the flight of birds caused me to stop, riveted with fear, and I stood stranded there, helpless, shivering, aware for the first time that I had been stricken by no mere pangs of withdrawal but by a serious illness whose name and actuality I was able finally to acknowledge. Going home, I couldn't rid my mind of the line of Baudelaire's, dredged up from the distant past, that for several days had been skittering around at the edge of my consciousness: 'I have felt the wind of the wing of madness.'

Robertson Davies 1992

Have we Canadians anything to say that
has not already been said, as well or better,
by others? We have only to say what
mankind has always said in its literature.
Our themes are Love, War and Death, and
we write of these things in our own way,
without fretting about originality or
novelty, both of which are fashionable
delusions. Every writer of worth, whether
poet, novelist or dramatist, writes of the
passions and aspirations of man
as he sees them; originality lies in himself,
far more than in the mode of life and racial
makeup of the people he writes about;
novelty lies in the quality of his perception
rather than in eccentricities of form.
Literature is renewed every time a writer of
individual observation and understanding
bends himself to his work, because he
speaks to his time; and perhaps if he is
a writer of high worth the time he speaks
to extends well beyond his nation and
possibly beyond the period of his own life.

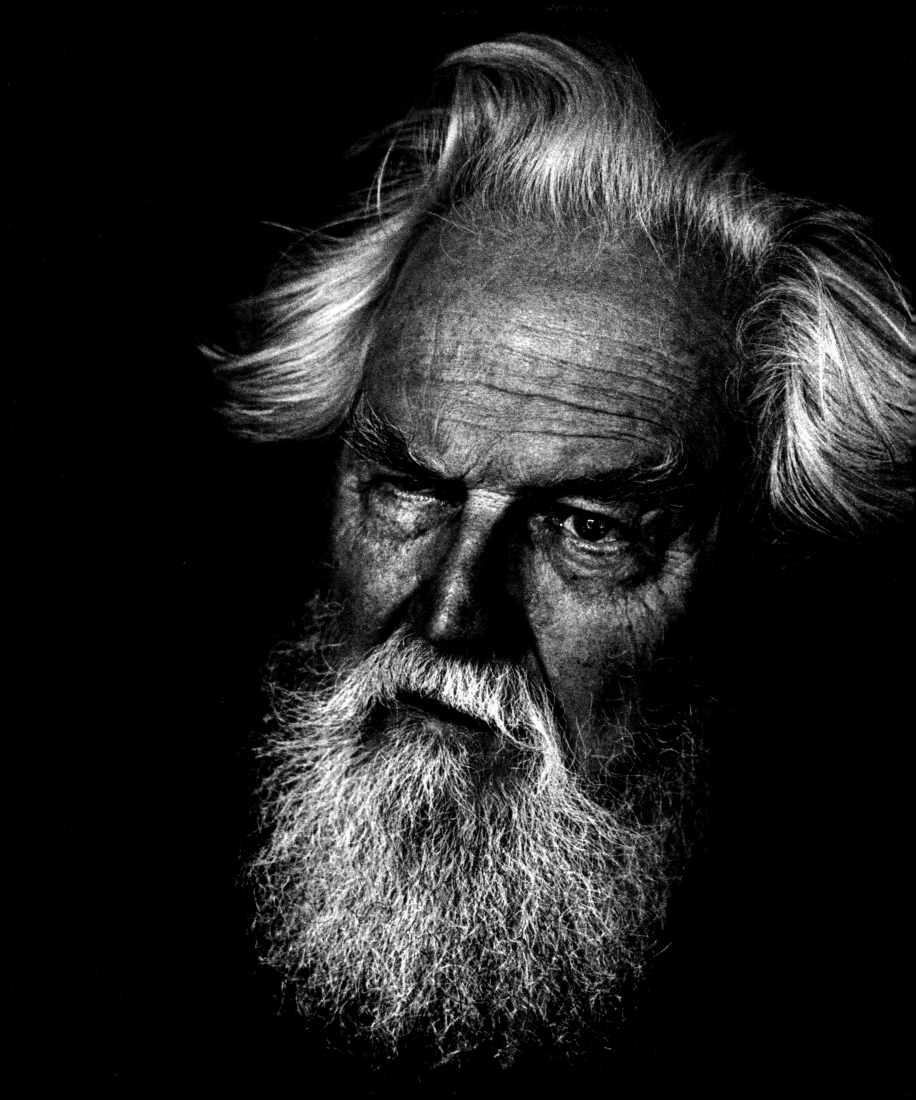

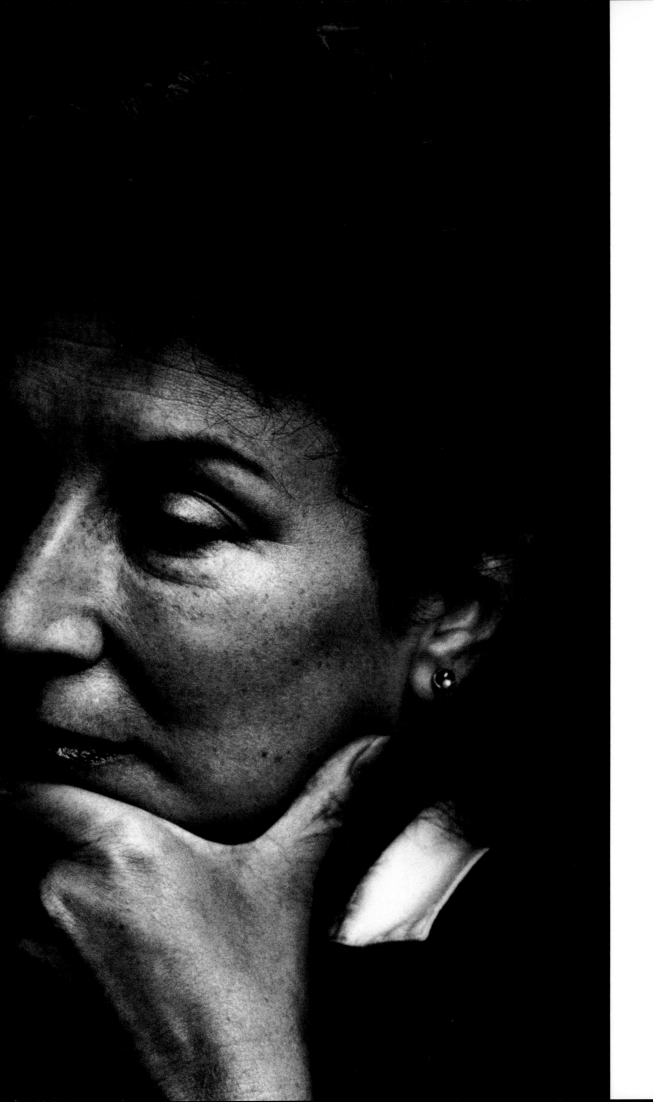

This Is A Photograph Of Me

It was taken some time ago.
At first it seems to be
a smeared
print: blurred lines and grey flecks
blended with the paper;

then, as you scan
it, you see in the left-hand corner
a thing that is like a branch: part of a tree
(balsam or spruce) emerging
and, to the right, halfway up
what ought to be a gentle
slope, a small frame house.

In the background there is a lake,
and beyond that, some low hills.

(The photograph was taken
the day after I drowned.

I am in the lake, in the center
of the picture, just under the surface.

It is difficult to say where
precisely, or to say
how large or small I am:
the effect of water
on light is a distortion

but if you look long enough,
eventually
you will be able to see me.)

Frederick Forsyth 1982

Elegy written in a Country Churchyard, by Thomas Gray

Beneath those rugged elms, that yew-tree's shade,
 Where heaves the turf in many a mouldering heap,
Each in his narrow cell for ever laid,
 The rude forefathers of the hamlet sleep.

Let not ambition mock their useful toil,
 Their homely joys, and destiny obscure;
Nor grandeur hear with a disdainful smile,
 The short and simple annals of the poor.

The boast of heraldry, the pomp of pow'r,
 And all that beauty, all that wealth e'er gave,
Awaits alike th' inevitable hour,
 The paths of glory lead but to the grave.

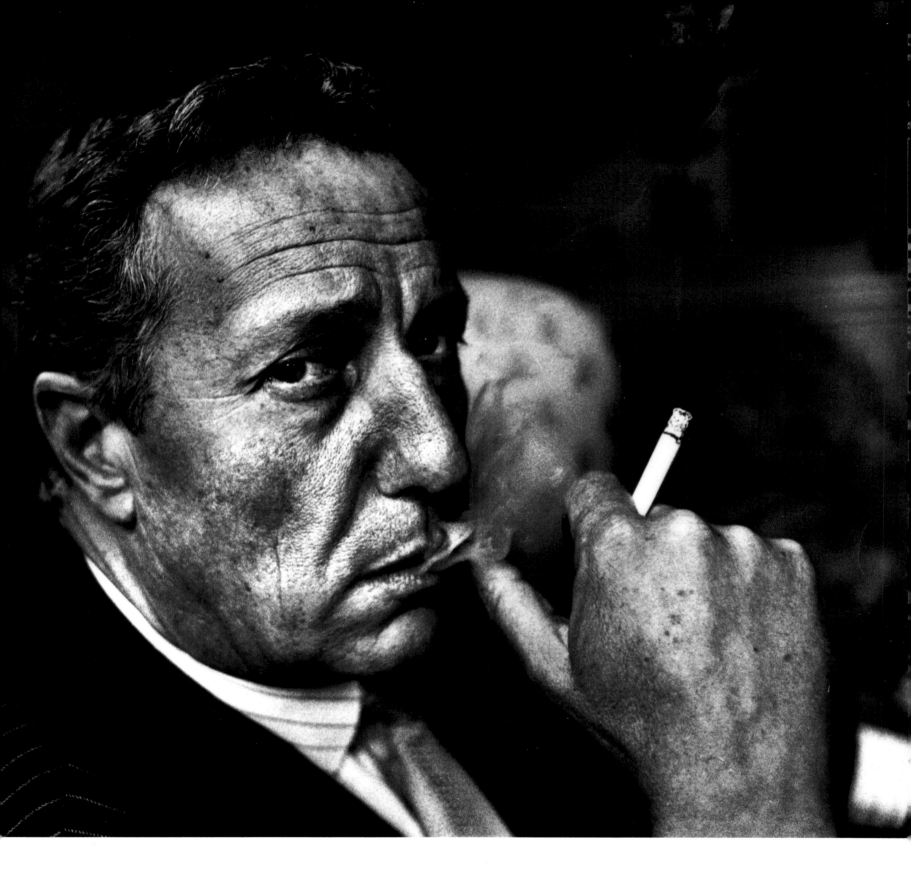

Tom Clancy 1990

*From lecture May 1980 on receiving
an honorary doctorate at Villanova
University*

Nothing is as real as a dream. The world
can change around you, but your dream
will not. Your life may change, but your
dream doesn't have to. Responsibilities
need not erase it. Duties need not obscure
it. Your spouse and children need not get
in its way, because the dream is within you.
No one can take your dream away.

Each of you has something that you want
to do with your life. It may serve others.
It might just make the world a better place.
But if nothing else, its fulfillment will help
to make you the person you want to be –
and everyone around you will profit by
that. Your dream is the path between the
person you are, and the person you hope
to become.

The only way that your dream can die
is if you kill it yourself. If you do that, you
will have condemned yourself along with it.
You will never be able to blame another
for that. Failure, like success, is something
that you will make for yourself. You will
always have that choice.

Success isn't money. At most, money
is nothing more than a convenient way
to keep score. Success isn't power. Power
is an illusion. The criteria for your success
are to be found in your dream, in your
self. These criteria are called ideals, and
as they are the substance of dreams, so
also is their achievement the definition
of success.

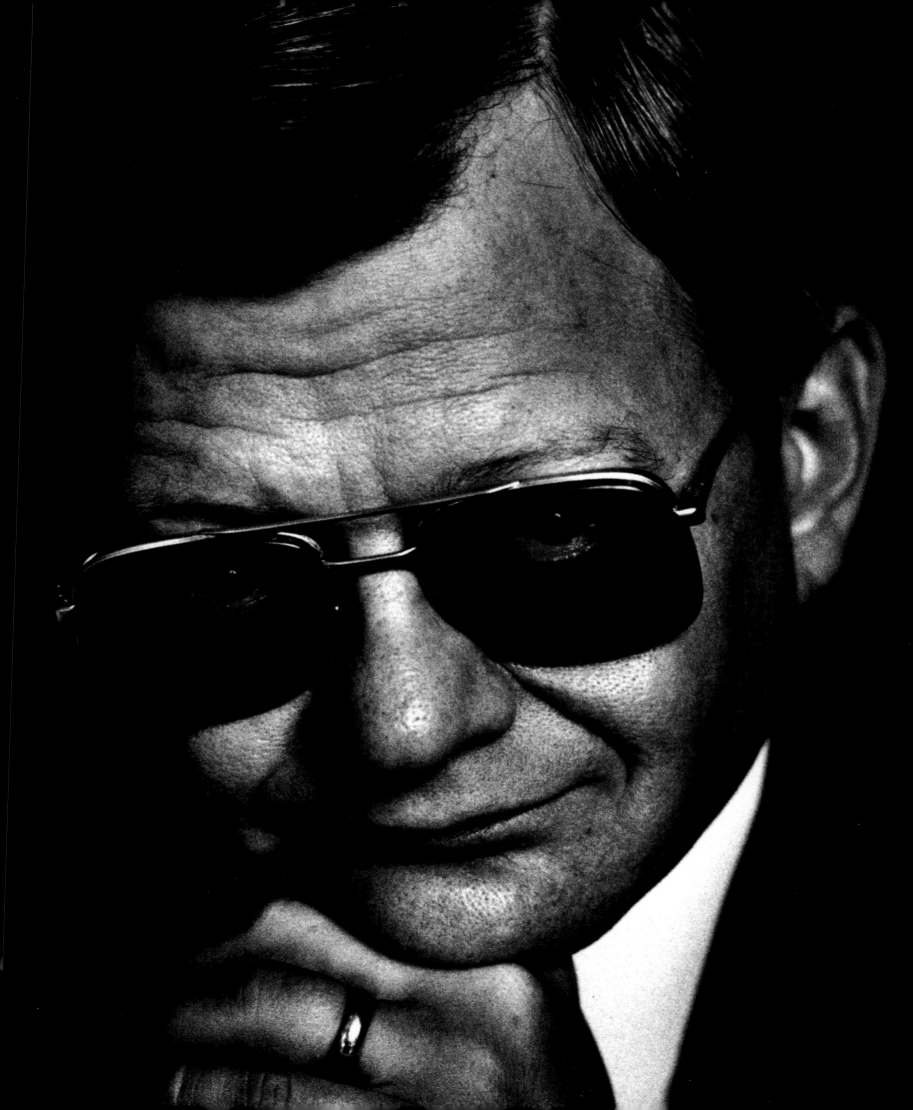

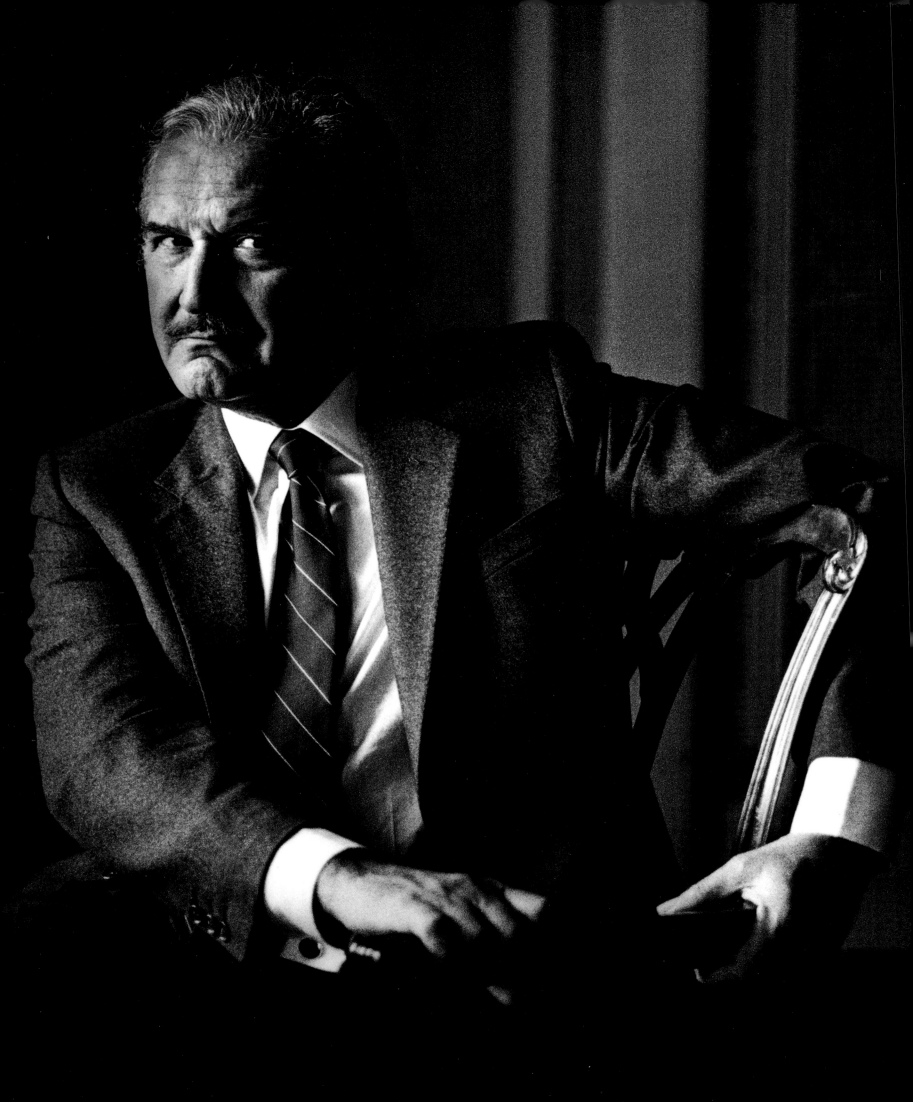

Carlos Fuentes 1990

Terra Nostra

'What is thought, is. What is, is thought.
I travel from spirit to matter. I return from
matter to spirit. There are no frontiers.
Nothing is forbidden me. I believe I am
several persons mentally. Then I am several
persons physically. I fall in love in a dream.
Then I encounter the loved being when
I awake. One lifetime is not sufficient.
Many existences are needed to fulfill
one personality. Reality is a sick dream.'

Maya Angelou 1993

Our Grandmothers

Centered on the world's stage,
she sings to her loves and beloveds,
to her foes and detractors:
However I am perceived and deceived,
however my ignorance and conceits,
lay aside your fears that I will be undone,

for I shall not be moved.

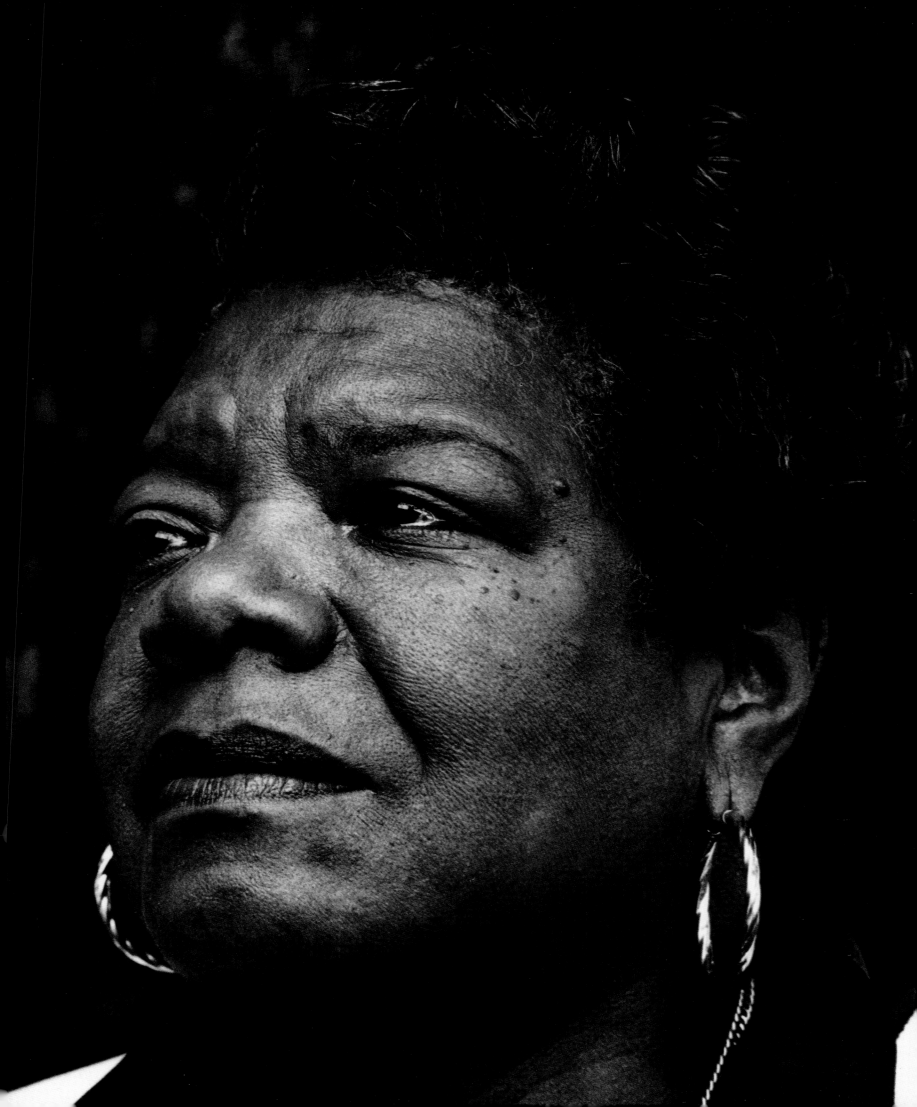

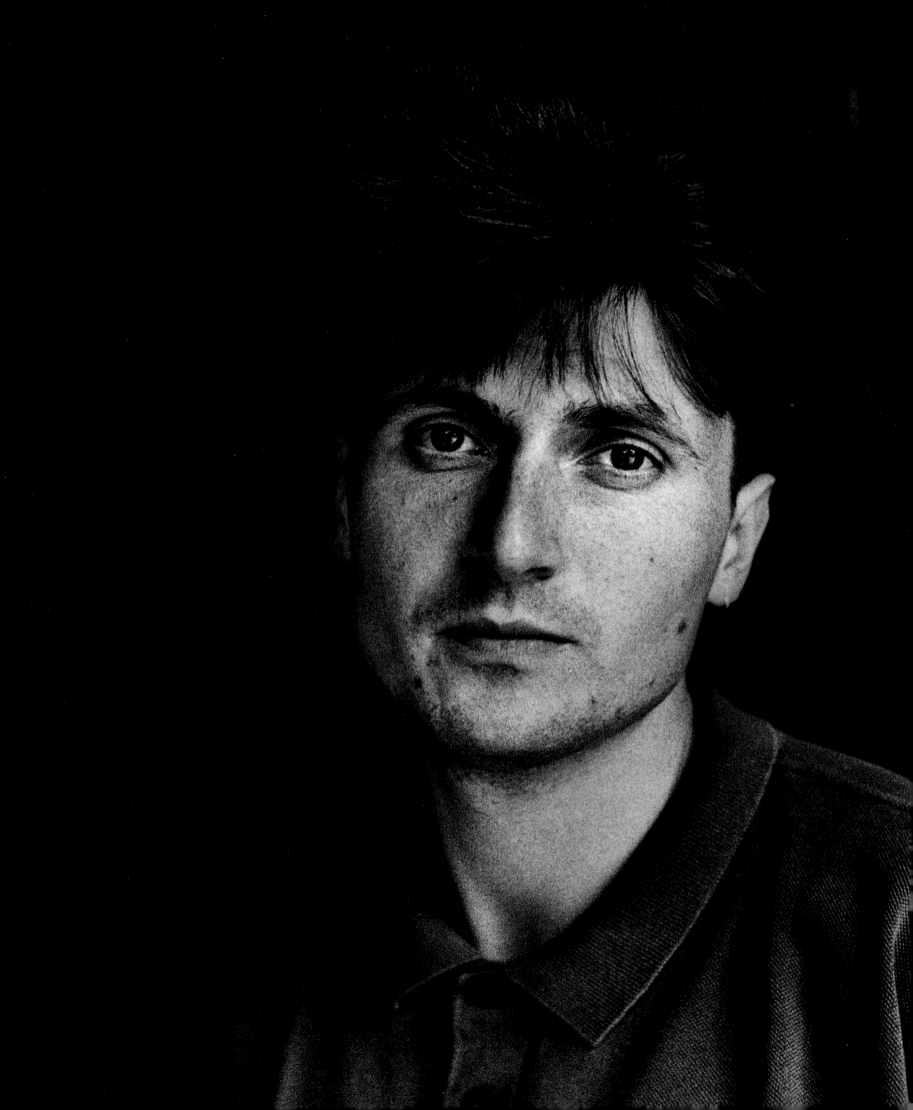

Simon Armitage 1992

*

My mind works
quickly and well these days
and I like the look of myself of late:

a little more meat
around the face, a little more bite
at the back of the lungs,
a little more point to the tip of the tongue –
no wonder I've been smiling
like a melon with a slice missing.

At twenty eight
I'm not doing great,
but considering I came from the River Colne
and its long, lifeless mud,
I'm doing good.

Anthony Powell 1990

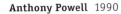

The Valley of the Bones

'… Oh, my brethren, think on that open
valley, think on it with me … a valley,
do I picture it, by the shaft of a shut-down
mine, where, under the dark mountain
side, the slag heaps lift their heads to the
sky, a valley such as those valleys in which
you yourselves abide … Journey with me,
my brethren, into that open valley, journey
with me … Know you not those same dry
bones? … You know them well … Bones
without flesh and sinew, bones without
skin and breath … They are our bones,
my brethren, the bones of you and of me,
bones that await the noise and the mighty
shaking, the gift of the four winds of which
the prophet of old did tell … Must we not
come together, my brethren, everyone of
us, as did the bones of that ancient valley,
quickened with breath, bone to bone,
sinew to sinew, skin to skin … Unless
I speak falsely, an exceeding great army …'

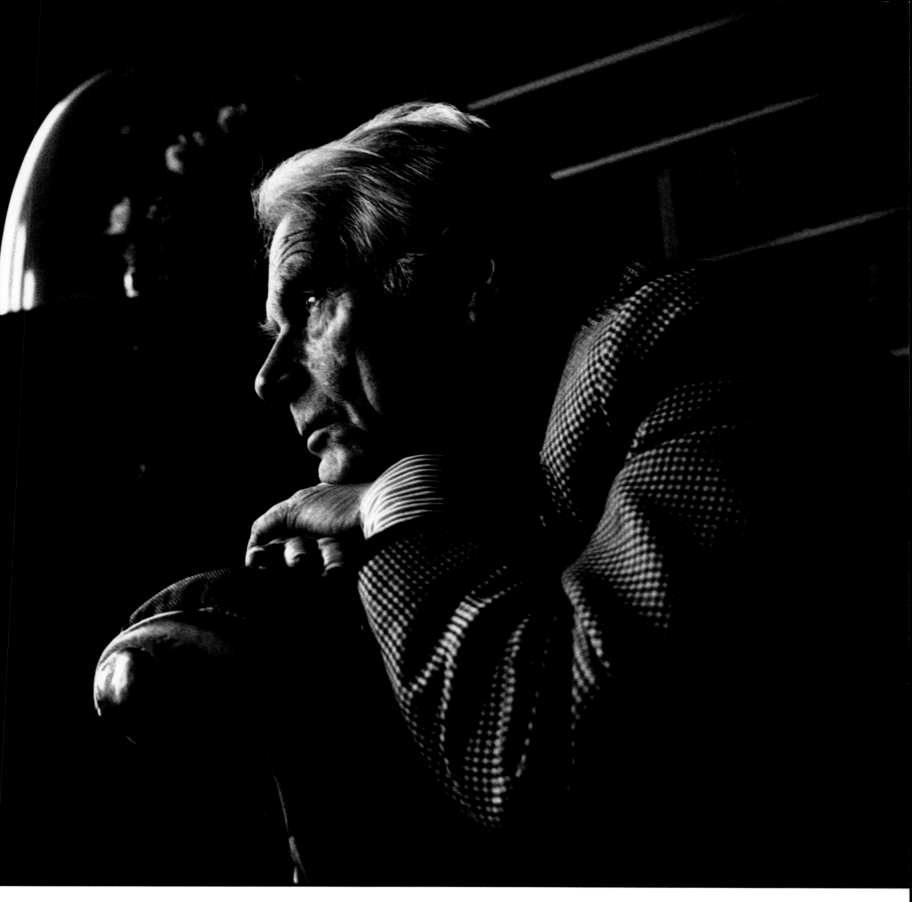

Laurens van der Post 1987

Venture to the Interior

Faith is the not-yet in the now:
It is a taste of the fruit that does not yet exist
Hanging the blossom on the bough.

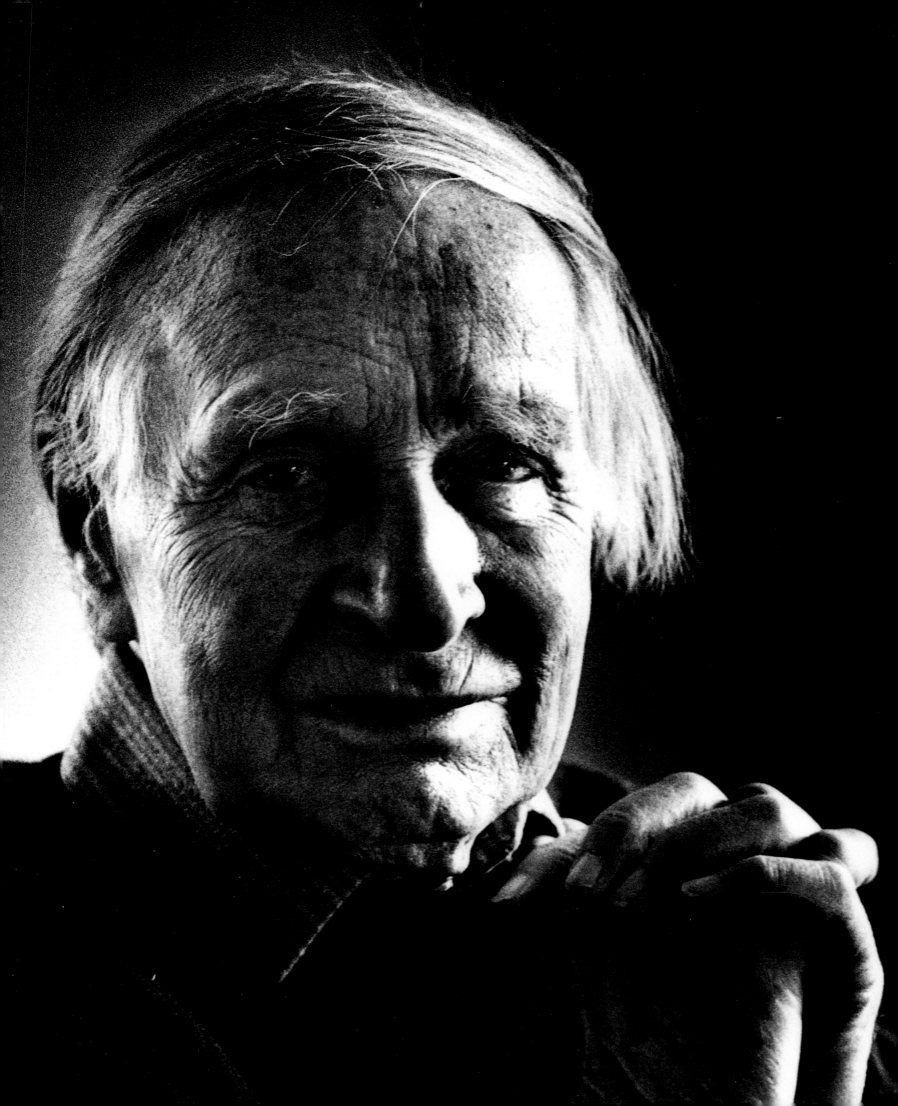

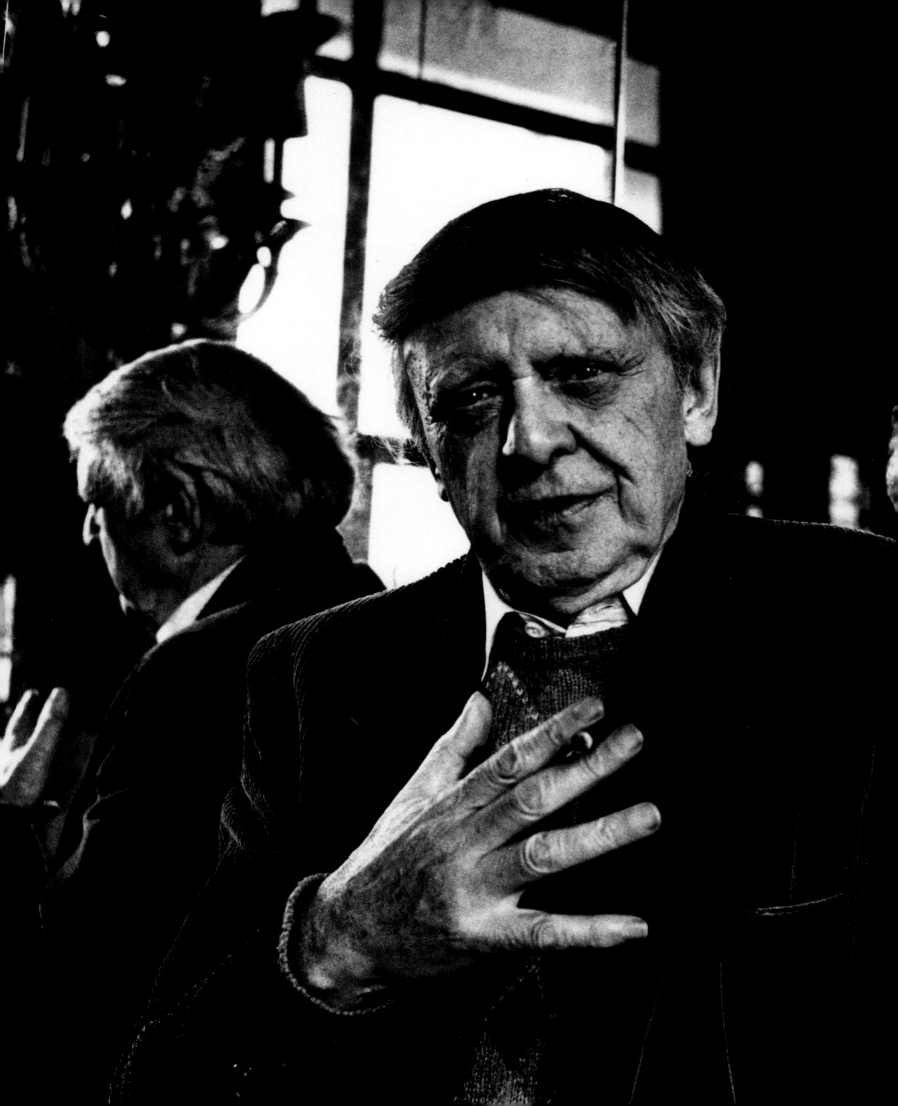

Anthony Burgess 1987

Earthly Powers

The sky was still emptying as we went to
bed. The thunder trundled over our roof
and, in the very instant of a blue flash,
I heard the crack and soaked leafy
multitudinous tumble of, surely, that oak
in Penney's field opposite. I waited, as
I always did, for my sister to settle to calm
breathing after her single barbiturate.
Then I turned, old bag of bones as I was,
on to my left side and addressed myself
to the brief slumber which would, I knew,
terminate with an hour's wait for the dawn
chorus. I contrived, you will perhaps
remember, an adequate beginning. I have
always, all through my literary career,
found endings excruciatingly hard. Thank
God, or something, the last words were
not for my pen and, thank that same
something, their scratching or sounding
could not, in the nature of things, be very
much longer delayed. I hoped there would
be no dreams.

Devices and Desires

... The cold moonlight, the constant
falling of the waves and the sense of
that stiffening body behind him induced
a gentle melancholy, a contemplation
of mortality including his own. *Timor
mortis conturbat me*. He thought: in
youth we take egregious risks because
death has no reality for us. Youth goes
caparisoned in immortality. It is only
in middle age that we are shadowed
by the awareness of the transitoriness
of life. And the fear of death, however
irrational, was surely natural whether
one thought of it as an annihilation
or as a rite of passage. Every cell in
the body was programmed for life; all
healthy creatures clung to life until
their last breath. How hard to accept,
and yet how comforting, was the gradual
realization that the universal enemy
might come at last as a friend. Perhaps
this was part of the attraction of his job,
that the process of detection dignified
the individual death, even the death of
the least attractive, the most unworthy,
mirroring in its excessive interest in
clues and motives man's perennial
fascination with the mystery of his
mortality, providing, too, a comforting
illusion of a moral universe in which
innocence could be avenged, right
vindicated, order restored, But nothing
was restored, certainly not life, and
the only justice vindicated was the
uncertain justice of men.

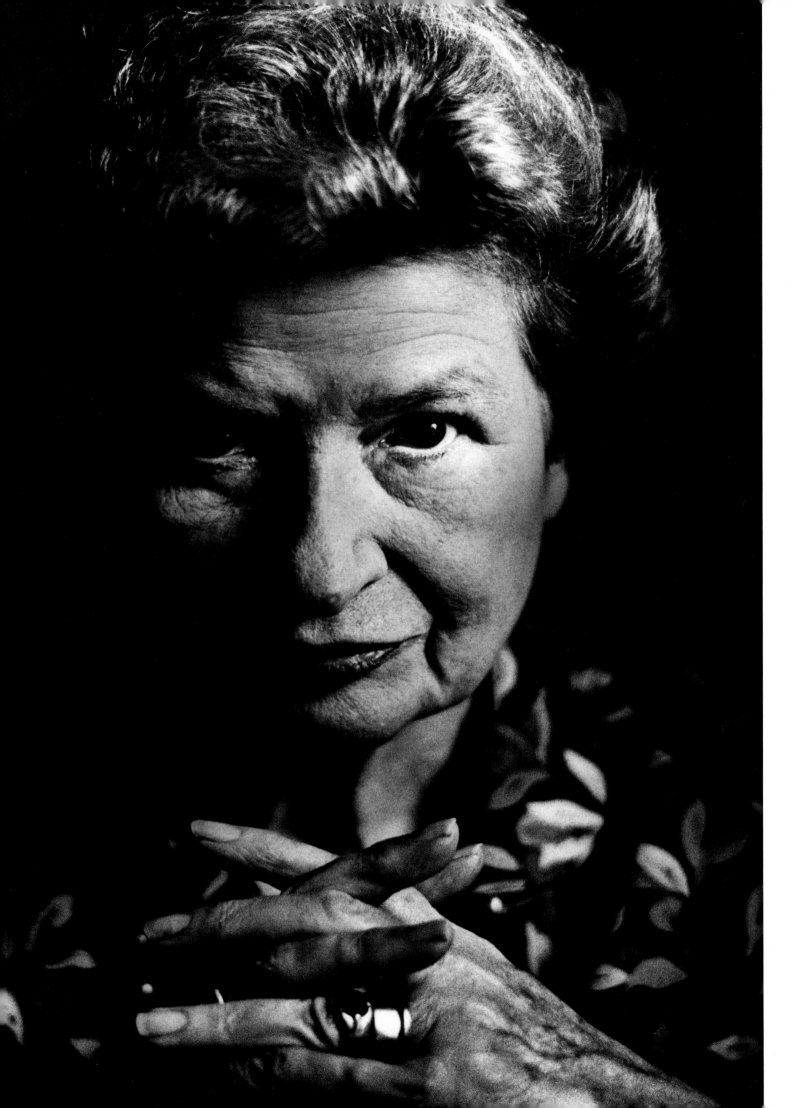

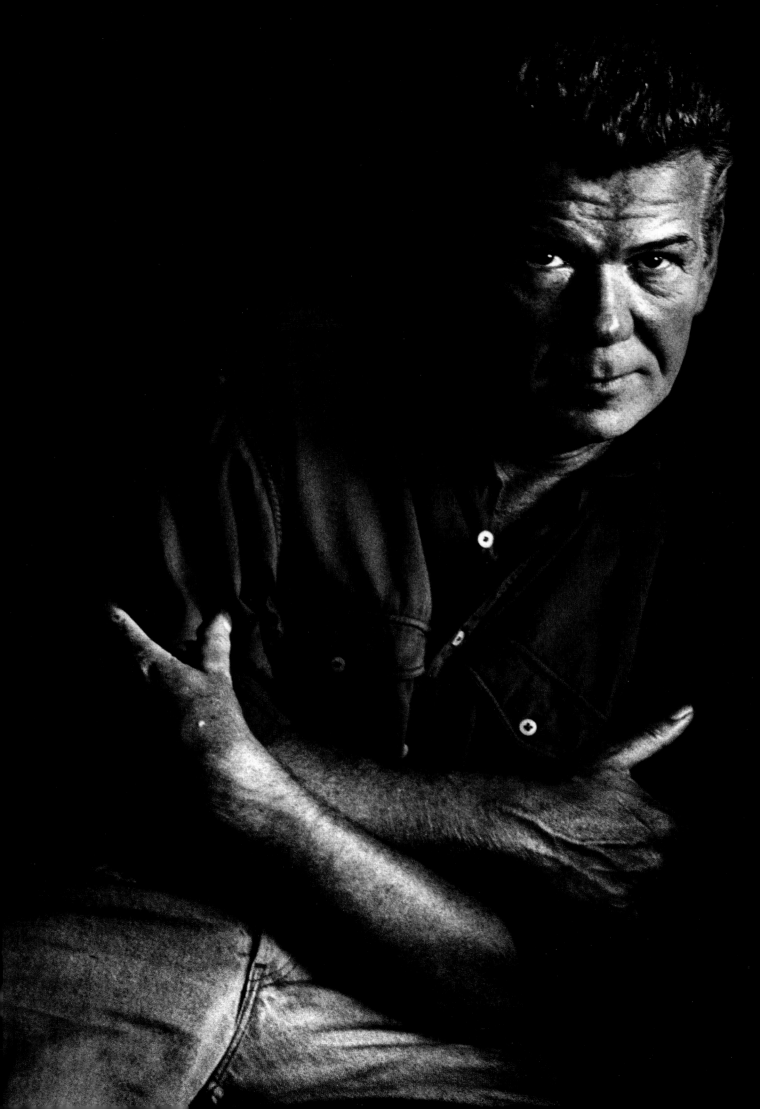

Winter Doves

People passed the end of the alley, and some even walked down it. One was a woman whose dog soiled Walter's shoe. Lovers passed. Time passed. Walter lay on his side in a foetal position, so that the whole of him was tucked inside a small doorway. He closed his eyes, and tried to rub the world out of his mind. When he woke he would draw it again on a large blackboard with white chalk. He would recreate the world in sharp white lines which everyone could understand. Then he would be able to see it clearly, and fit himself into it.

Walter set himself to imagine the drawing he would make of himself to fit into the blackboard world, but the self he saw was empty, an outline drawing of a man with a hat on.

Seventeen days of alternating light and darkness, comparative warmth and hard cold, weeping and thinking of June and of Walter and June, and perpetual hammering questions asked by a mind which knew it could not supply the answers. *I must have food or I die.* He uncurled and set himself again in movement, and walked out of the alley, and came to the Spike, and must now endure the forms and procedures of the Spike, and the people of the Spike, who were so clearly of the real world.

George V Higgins 1985

The Mandeville Talent

The man pulled the trigger. The pellets in
a load of number 6 birdshot cover a thirty-
inch circle when they are fired from a
shotgun bored or choked to full, at fifty
feet. The pellets in the shell the man fired
from the Browning with its muzzle against
the flesh of James Mandeville's lower jaw
emerged at nearly 900 feet per second in
a group approximately three quarters of
an inch wide and dispersed only slightly
before they collided with the maxillary,
zygomatic, nasal temporal, parietal, and
frontal bones of his head, so that the force
that carried them sufficed to blow out
the back of his head against the wall and
the mirror over the sink – it cracked on
the impacts of the bone fragments and
emerging pellets.

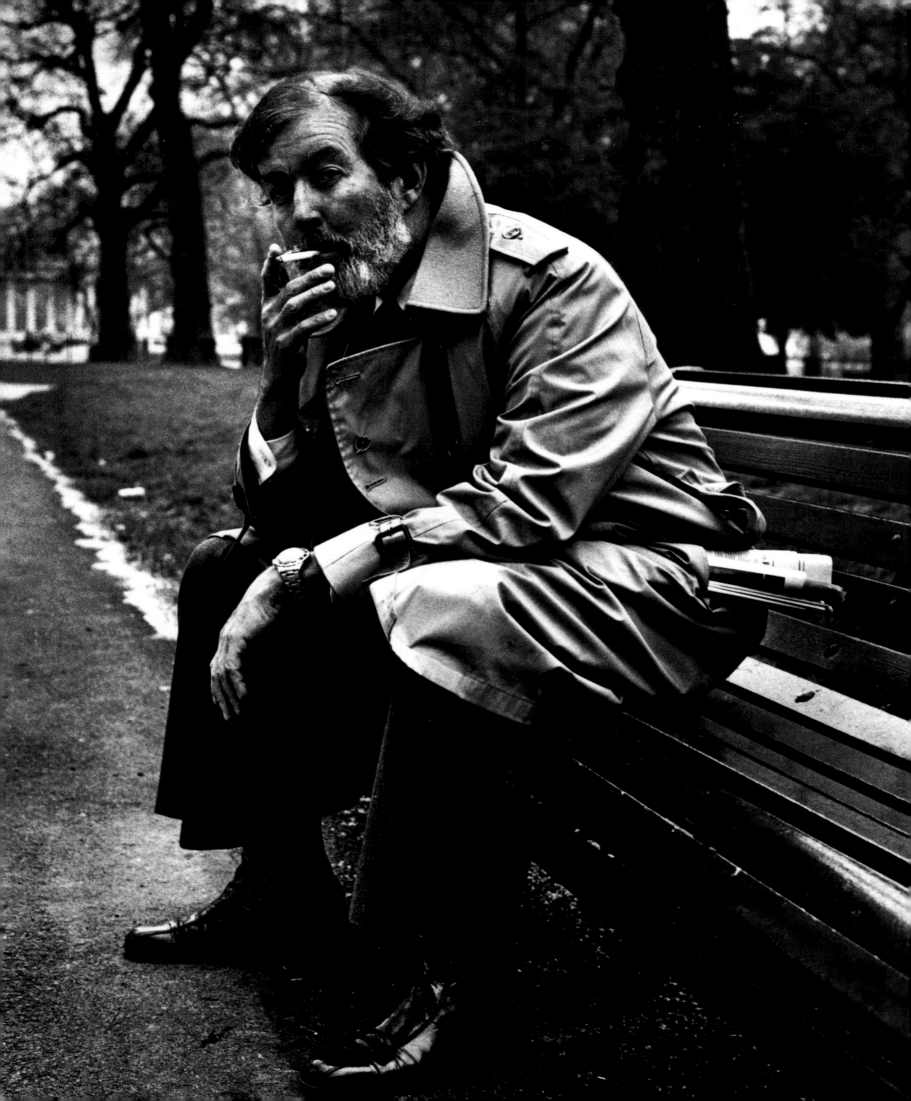

Helene Hanff 1991

84, Charing Cross Road

14 East 95th St
New York City

April 16, 1951

To All at 84, Charing Cross Road:

Thank you for the beautiful book. I've
never owned a book before with pages
edged all round in gold. Would you believe
it arrived on my birthday?

I wish you hadn't been so over-courteous
about putting the inscription on a card
instead of on the flyleaf. It's the bookseller
coming out in you all, you were afraid
you'd decrease its value. You would
have increased it for the present owner.
(And possibly for the future owner. I love
inscriptions on flyleaves and notes in
margins, I like the comradely sense of
turning pages someone else turned, and
reading passages some one long gone has
called my attention to.)

And why didn't you sign your names?
I expect Frank wouldn't let you, he
probably doesn't want me writing love
letters to anybody but him.

I send you greetings from America –
faithless friend that she is, pouring
millions into rebuilding Japan and Germany
while letting England starve. Some day,
God willing, I'll get over there and
apologize personally for my country's sins
(and by the time I come home my country
will certainly have to apologize for mine).

Thank you again for the beautiful book,
I shall try very hard not to get gin and
ashes all over it, it's really much too fine
for the likes of me.

Yours,
Helene Hanff

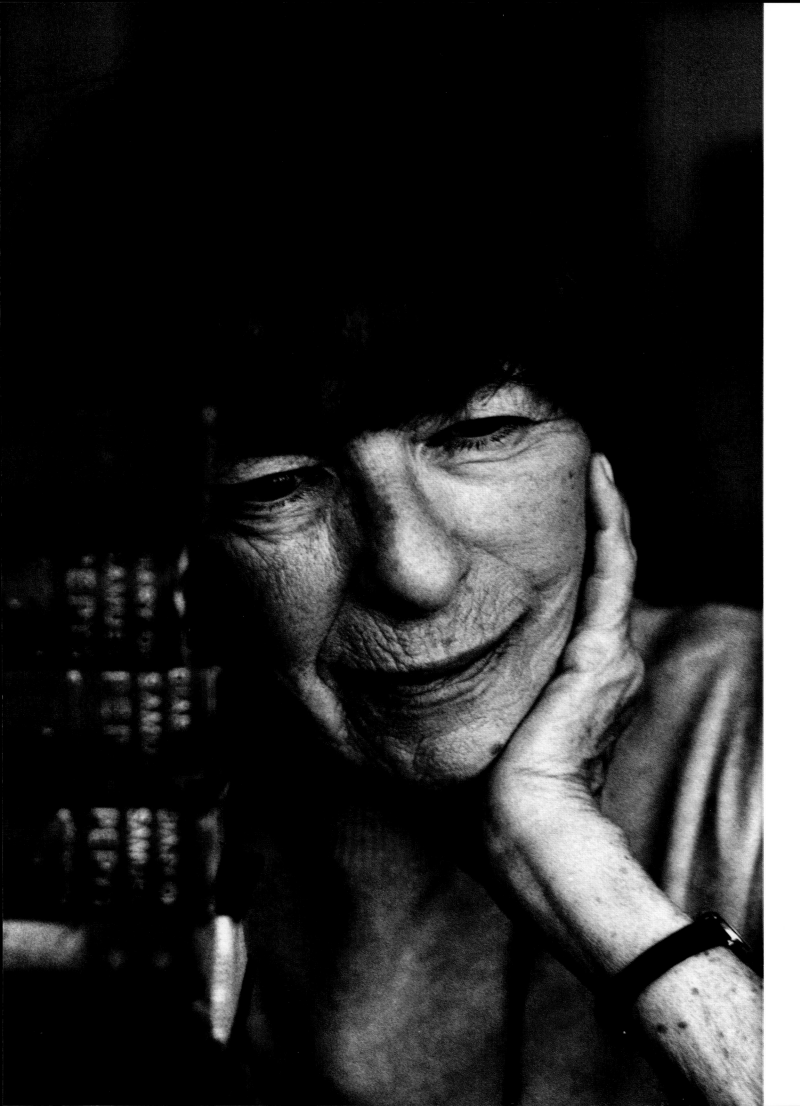

The Image Trade

One more half-hearted click from
the camera, and then Zut stood tall.
He had achieved boredom.

'I've got all I want,' he muttered sharply
to his wife.

All? said Pearson, appealing. There are
tons of me left. I know I have a face like
a cup of soup with handles sticking out –
you know? – after it has been given
a couple of stirs with a wooden spoon.
A speciality in a way. What wouldn't
I give for bone structure, a nose with
bone in it!

Zut gave a last dismissive look around
the room.

'That's it,' he said to his wife.

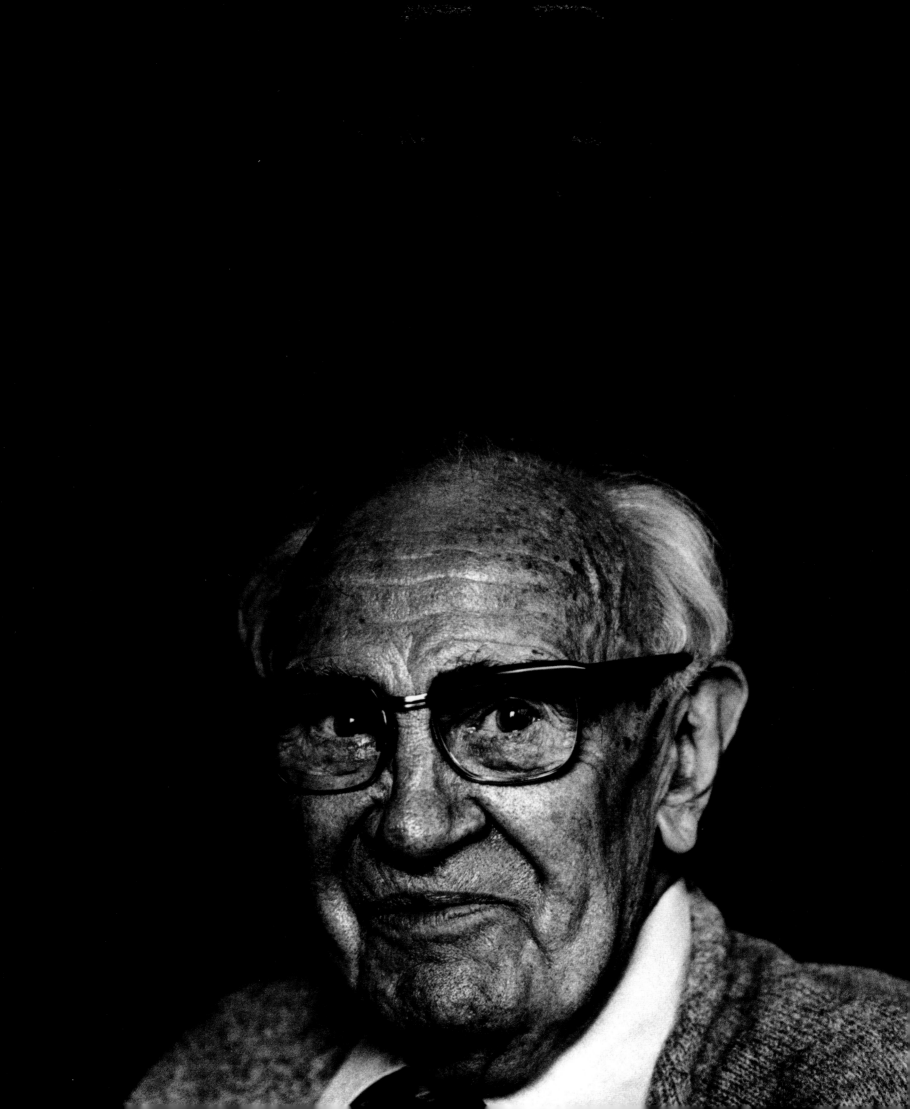

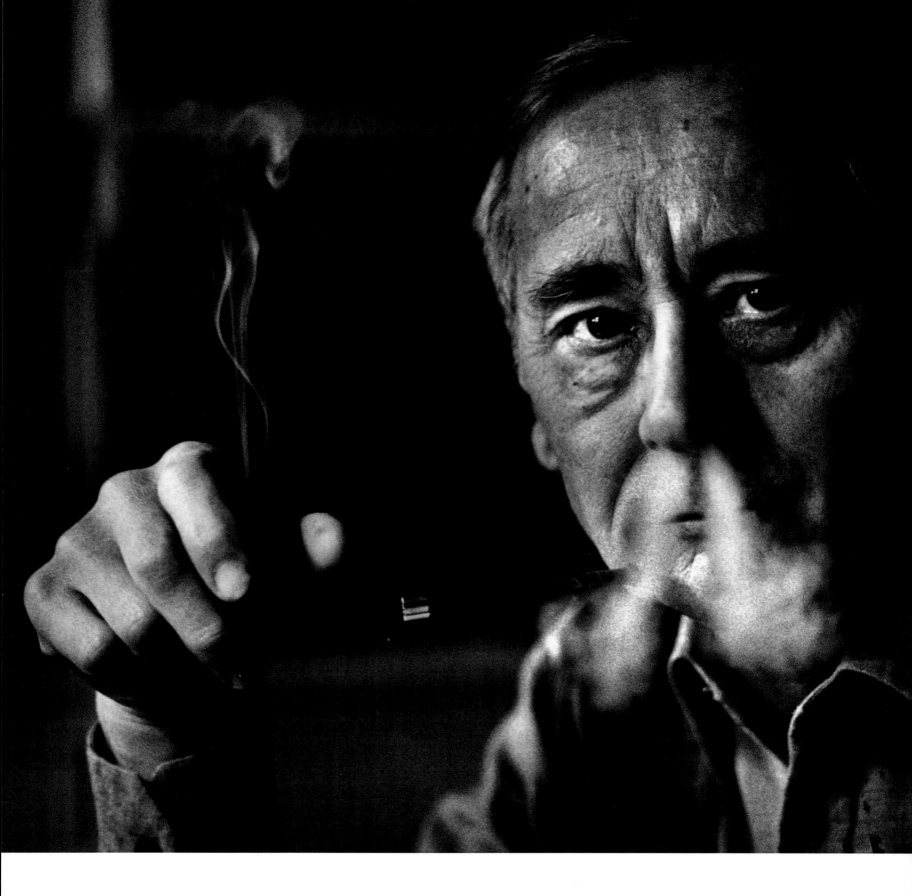

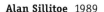

Life Without Armour

"While completing the final version
of 'Saturday Night and Sunday Morning'
I lived (in Majorca) as if the England,
which I loved but did not especially like,
had little to offer. A miasma of falsity was
spread by those who assumed that their
opinions were the same as everyone else's,
and therefore the only ones that mattered,
such hypocrisy stifling every aspect of
life. These purveyors of conformism did
not know about the great majority of the
people, and did not care to consider them
as worthy of notice. When they did not
fear or hate them, they wanted them
to be in perpetual thrall to values which
the complacent upper few per cent had
decided, because they were their own,
were the only ones worth living by. This
included those socialists and left-wing
commentators who also thought they knew
how people ought to live, but would never
live like it themselves. The country was
dead from the neck up, and the body was
buried in sand, waiting for someone to
illuminate those views and values which
they were being told in a thousand ways
were something to be ashamed of and
ought never to be expressed. In the age
of mass media cultural variations, called
fashion, come and go, but the eternal
values override them and remain, which
is the same today as it was then."

Paths from a White Horse:
A Writer's Memoir

1923. I was three. A White Horse lay
bare and solitary, cut into a hillside.
It changes whenever I return to it, like
a book, painting, friend, but remains
fixed in my imagination, a reminder
of the multiple transformations that
enthuse life. All is provisional. Memory
contracts and enlarges as if in a dream
that does not cease in the morning.

Adults seemed strangely unaware of the
White Horse or reluctant to mention it.
Here, already, was the first of the
countless secrets that helped to awaken
me. The Horse, existing without breathing
or eating, though, in days of shadow and
sun, it sometimes appeared to move,
seemed mysteriously more real than an
actual white horse assiduously cropping
the pasture.

Such feelings, of course, are common-
place. A little girl at Wellington's funeral,
seeing the Duke's boots dangling from
his horse, asked whether all people got
turned into boots. A small boy, he could
have been me, seeing the statue of General
Gordon on a camel, eventually asked the
name of the man sitting on Gordon.
Children can weep, not for joy at the
Prodigal Son's return, but in grief for the
fatted calf. They speak for moods into
which adults too can periodically relapse
and which dictators may cynically
understand, though understand little else.
Absolute power demands the childish,
occasionally the child-like.

Sacred Country

Mary:
I can remember way back, almost to when
I was born.

I can remember lying in my parents' bed,
jammed between them. It was an iron bed
with a sag in the middle. They put me into
the sag and gravity made them fall towards
me, wedging me in.

Our land was full of stones. As soon as
I could walk, I was given a bucket with a
picture of a starfish on it and told to pick
stones out of the earth. My father would
walk ahead with a big pail so heavy he
could barely carry it. I think he thought
about the stones all the time and he tried
to make me think about them all the time.
I was supposed to take my starfish bucket
with me wherever I went and have my
mind on the stones.

I can remember getting lost in a flat
field. It was winter and the dark came
round me and hid me from everything and
swallowed up my voice. The only thing
I could see was my bucket, which had
a little gleam on it, and the only thing
I could hear was the wind in the firs.
I began to walk towards the wind, calling
to my father. I walked right into the trees.
They sighed and sighed. I put my arms
round one of the scratchy fir trunks and
stayed there, waiting. I thought Jesus
might come through the wood holding
up a lantern.

My parents came and found me with
torches. My mother was sobbing. My
father picked me up and wrapped me
inside his old coat that smelled of seed.
He said: 'Mary, why didn't you stay
where you were?' I said: 'My bucket is
lost on the field.' My father said: 'Never
mind about the bucket. You're the one.'

But when I was three, I was no longer
the one. Tim was born and my father
kept saying the arrival of Timmy was
a miracle. I asked my mother whether
I had been a miracle and she said: 'Oh,
men are like that, especially farmers.
Pay no heed.'

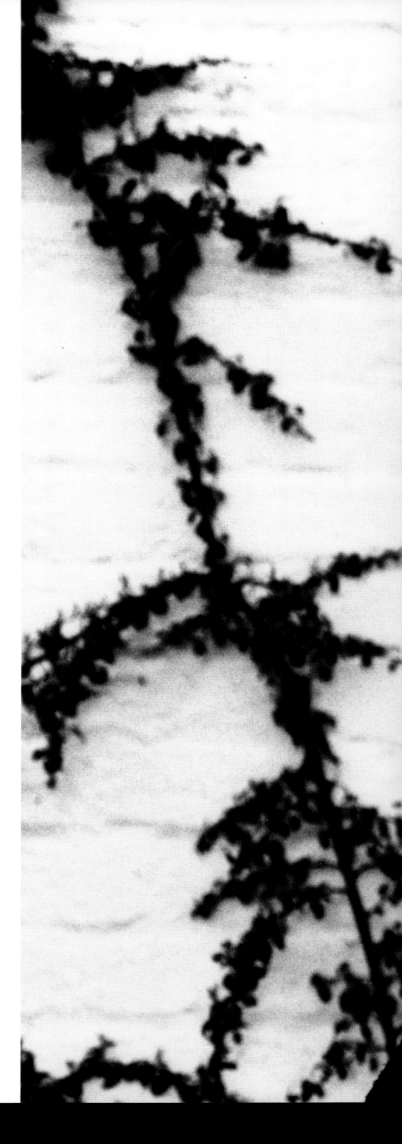

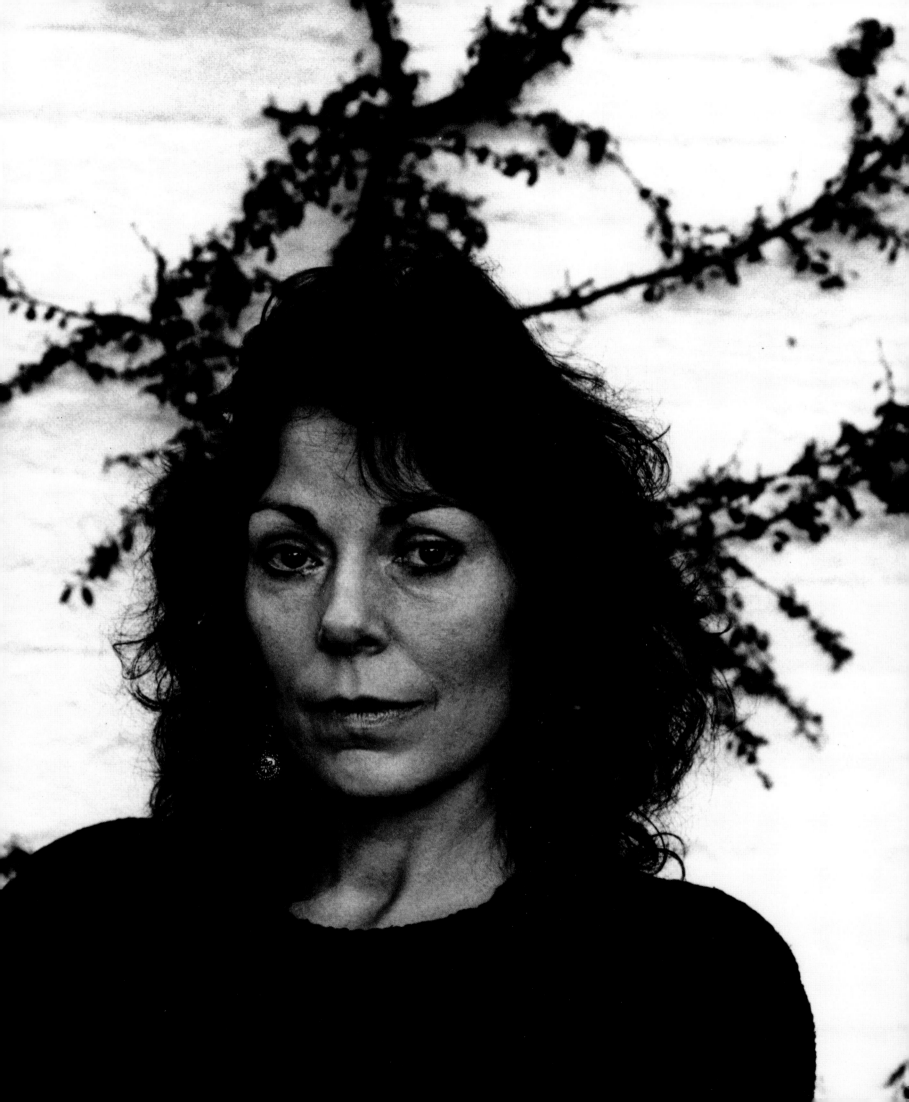

Julian Barnes 1989

Flaubert's Parrot

Why does the writing make us chase the
writer? Why can't we leave well alone? Why
aren't the books enough? Flaubert wanted
them to be: few writers believed more in
the objectivity of the written text and the
insignificance of the writer's personality,
yet still we disobediently pursue. The
image, the face, the signature: the 93
per cent copper statue and the Nadar
photograph; the scrap of clothing and
the lock of hair. What makes us randy for
relics? Don't we believe the words enough?
Do we think the leavings of a life contain
some ancillary truth? When Robert Louis
Stevenson died, his business-minded
Scottish nanny quietly began selling hair
which she claimed to have cut from
the writer's head forty years earlier. The
believers, the seekers, the pursuers bought
enough of it to stuff a sofa.

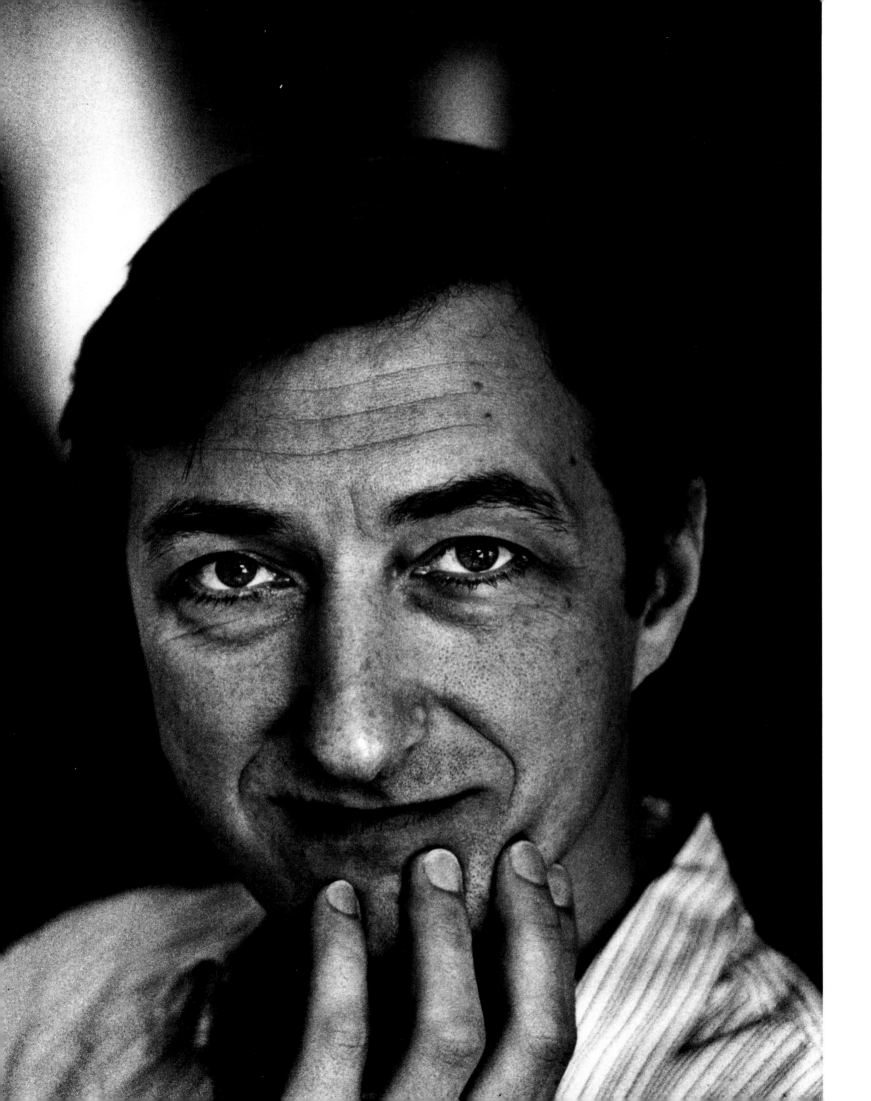

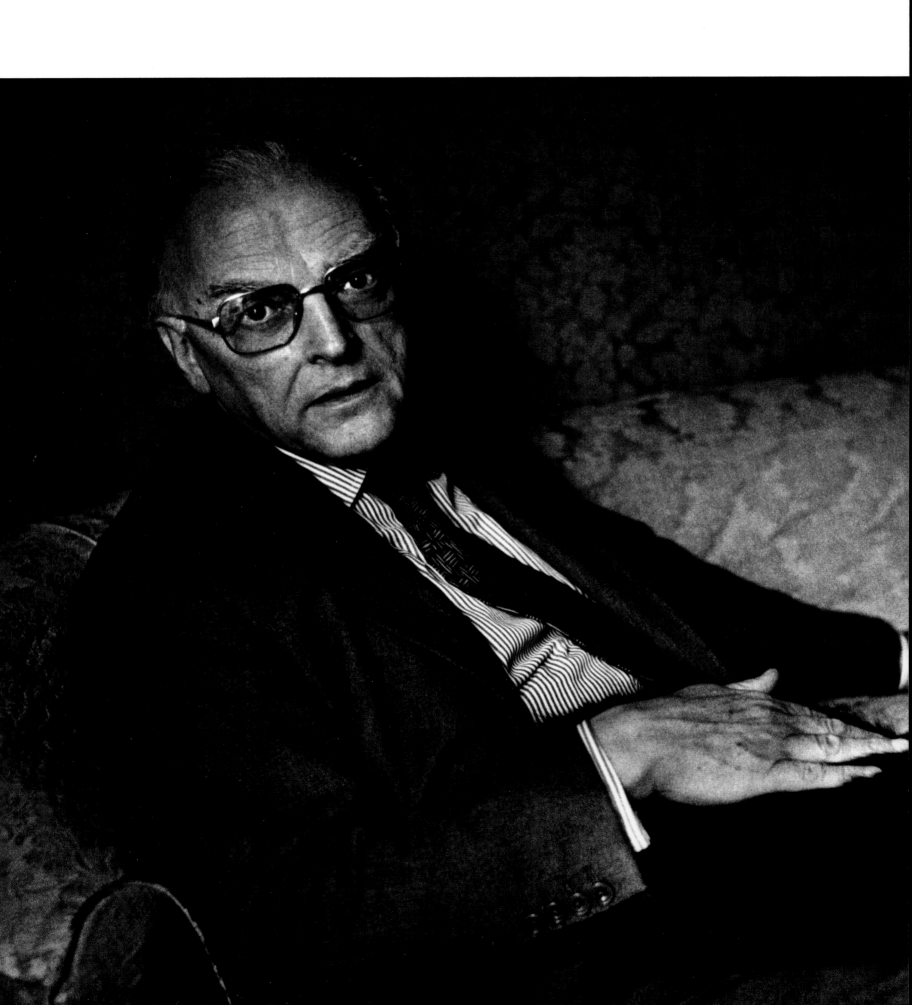

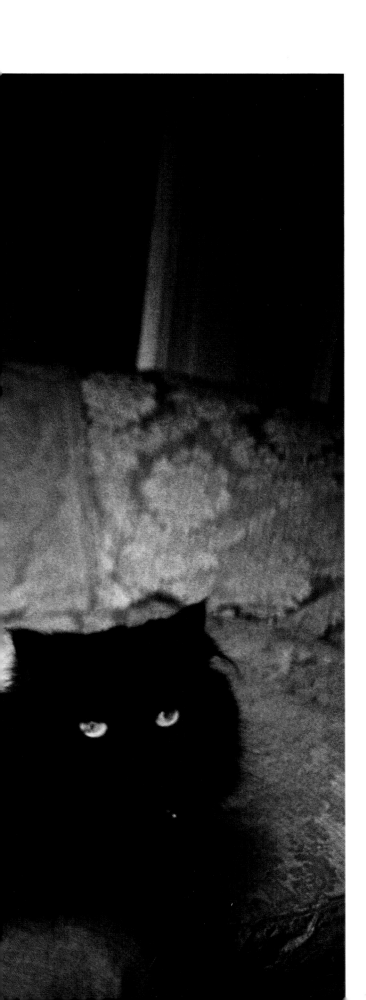

His Everlasting Mansion

... Above the last of my mansions,
on the last of my islands, there writhes
a fig-tree long since dead and even longer
barren. One day I shall have learned again
to love myself enough to throw over the
strongest of its branches the rope that
the dog drags around with him, and to
hang first him, so humane in his simple
bestiality, and then myself, so beastly
in my complex humanity. When that hour
comes, these scraps of paper, as illusory
as those other scraps piled high in
innumerable banks in innumerable cities
of the world, will have to stand as my
gravestone.

But there is enough time for that. Of time,
as of the filth of the world and of the world
of filth, there is always enough.

The Throwback

'You say,' continued the old man, 'as well you may, if inheritance determines temperament what has education to do with what we are? Is that not what you are thinking?'

Again Mrs Flawse nodded involuntarily. Her own education had been so pasteurized by permissive parents and progressive teachers that she found it impossible to follow his argument at all. Beyond the fact that he seemed obsessed with the sexual habits and reproductive processes of dogs and had openly admitted that in the Flawse family a dog was evidently the father to the man, she had no idea what he was talking about.

'The answer is this, ma'am, and here again the dog is our determinant, a dog is a domestic animal not by nature but by social symbiosis. Dog and man, ma'am, live together by virtue of mutual necessity. We hunt together, we eat together, we live together and we sleep together, but above all we educate one another. I have learnt more from the constant companionship of dogs than ever I have from men or books. Carlyle is the exception but I will come to that later. First let me say that a dog can be trained. Up to a point, ma'am, only up to a point. I defy the finest shepherd in the world to take a terrier and turn him into a sheepdog. It can't be done. A terrier is an earth dog. Your Latin will have acquainted you with that. Terra, earth; terrier, earth dog. And no amount of herding will eradicate his propensity for digging. Train him how you will he will remain a digger of holes at heart. He may not dig but the instinct is there. And so it is with man, ma'am. Which said, it remains only to say that I have done with Lockhart my utmost to eradicate those instincts which we Flawses to our cost possess.'

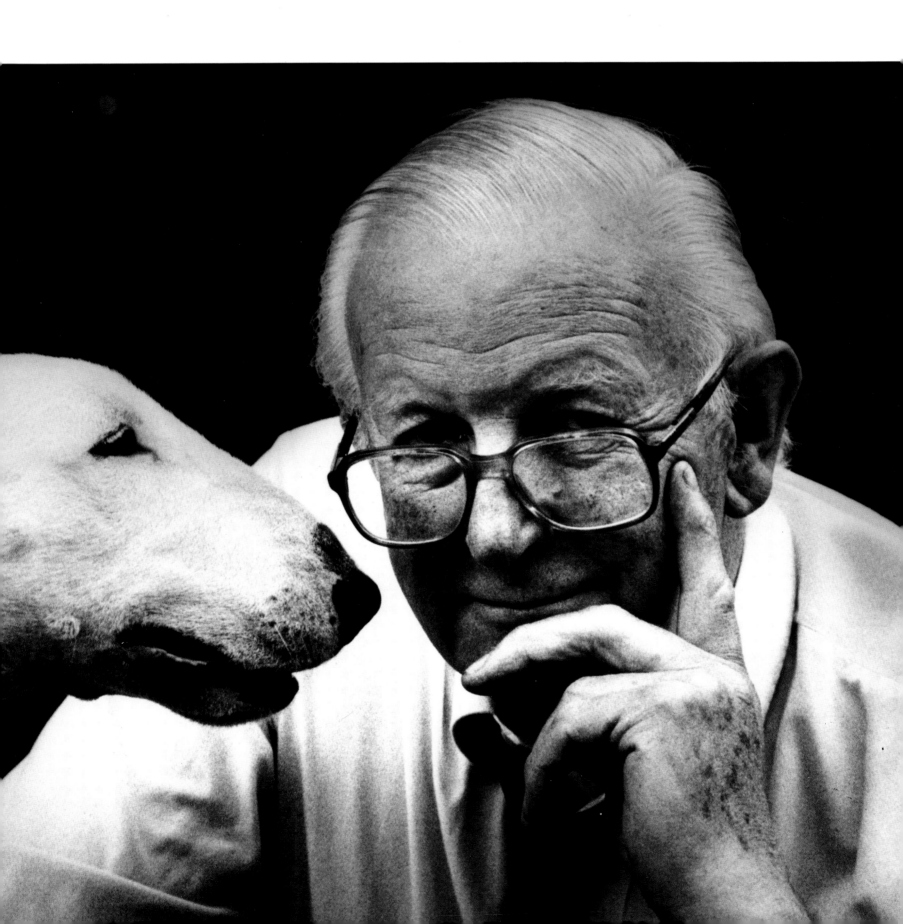

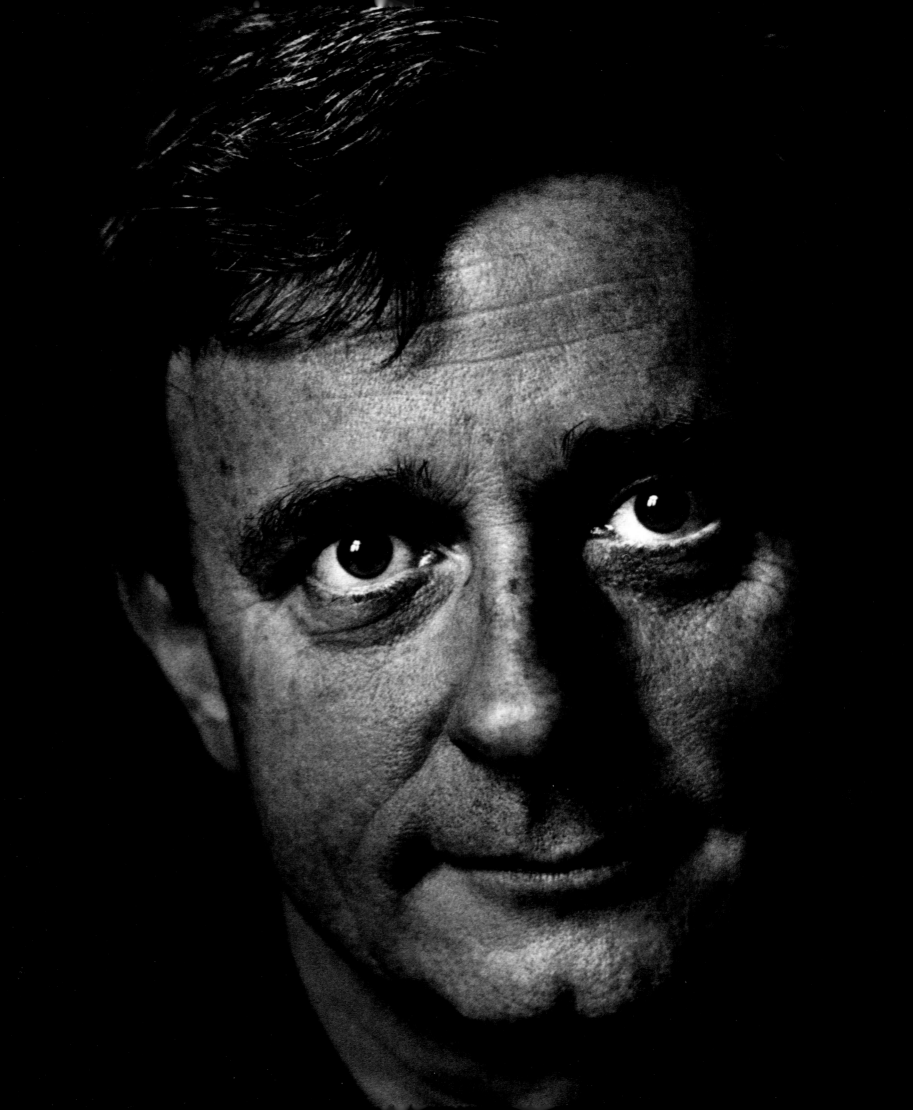

Edmund White 1987

Lolita, by Vladimir Nabokov

She closed her eyes and opened her mouth, leaning back on the cushion, one felted foot on the floor. The wooden floor slanted, a little steel ball would have rolled into the kitchen. I knew all I wanted to know. I had no intention of torturing my darling. Somewhere beyond Bill's shack an afterwork radio had begun singing of folly and fate, and there she was with her ruined looks and her adult, rope-veined narrow hands and her goose-flesh white arms, and her shallow ears, and her unkempt armpits, there she was (my Lolita!), hopelessly worn at seventeen, with that baby, dreaming already in her of becoming a big shot and retiring around AD 2020 – and I looked and looked at her, and knew as clearly as I know I am to die, that I loved her more than anything I had ever seen or imagined on earth, or hoped for anywhere else. She was only the faint violet whiff and dead echo of the nymphet I had rolled myself upon with such cries in the past; an echo on the brink of a russet ravine, with a far wood under a white sky, and brown leaves choking the brook, and one last cricket in the crisp weeds … but thank God it was not that echo alone that I worshipped. What I used to pamper along the tangled vines of my heart, *mon grand péché radieux,* had dwindled to its essence: sterile and selfish vice, all that I cancelled and cursed. You may jeer at me, and threaten to clear the court, but until I am gagged and half-throttled, I will shout my poor truth. I insist the world know how much I loved my Lolita, this Lolita, pale and polluted, and big with child, but still grey-eyed, still sooty-lashed, still auburn and almond, still Carmencita, still mine; *Changeons de vie, ma Carmen, allons vivre quelque part ou nous ne serons jamais séparés;* Ohio? The wilds of Massachusetts? No matter, even if those eyes of hers would fade to myopic fish, and her nipples swell and crack and her lovely young velvety delicate delta be tainted and torn – even then I would go mad with tenderness at the mere sight of your dear wan face, at the mere sound of your raucous young voice, my Lolita.

To Know a Woman

Yoel picked the object up from the shelf and inspected
it closely. His eyes ached. The agent, thinking he had
not heard the question, repeated it: 'Shall we go
and take a look round the back?' Even though he
had already made up his mind, Yoel was in no hurry
to reply. He was in the habit of pausing before
answering, even simple questions such as How are
you? or What did it say on the news? As though words
were personal possessions that should not be parted
with lightly.

The agent waited. And in the meantime there was a
silence in the room, which was stylishly furnished:
a wide, deep-pile, dark blue rug, armchairs, a sofa, a
mahogany coffee table, an imported television set,
a huge philodendron in the appropriate corner,
a red-brick fireplace with half a dozen logs arranged
in criss-cross fashion, for show rather than use. Next
to the serving hatch to the kitchen, a dark dining
table with six matching high-backed dining chairs.
Only the pictures were missing from the walls, where
pale rectangles were visible. The kitchen, seen though
the open door, was Scandinavian and full of the latest
electrical gadgets. The four bedrooms, which he had
already seen, had also met with his approval.

With his eyes and fingers Yoel explored the thing he
had taken off the shelf. It was a carving, a figurine,
the work of an amateur: a feline predator, carved
in brown olive wood and coated with several layers
of lacquer. Its jaws were gaping wide and the teeth
were pointed. The two front legs were extended in
the air in a spectacular leap; the right hind leg was
also in the air, still contracted and bulging with
muscles from the effort of jumping, only the left hind
leg preventing the takeoff and grounding the beast
on a stainless-steel stand. The body rose at an angle
of forty-five degrees, and the tension was so powerful
that Yoel could almost feel in his own flesh the pain
of the confined paw and the desperation of the
interrupted leap. He found the statuette unnatural
and unconvincing, even though the artist had
succeeded in imposing on the wood an excellent feline
litheness. This was not the work of an amateur after
all. The details of the jaws and the paws, the twist
of the springlike spine, the tension of the muscles,
the arching of the belly, the fullness of the diaphragm
inside the strong ribcage, and even the angle of the
beast's ears, swept back, almost flattened towards
the back of the head – all the detailed work was
excellent and evinced a mastery of the secret of
defying the limitations of matter. This was evidently
an accomplished piece of carving, liberated from its
woodenness and achieving a cruel, fierce, almost
sexual vitality.

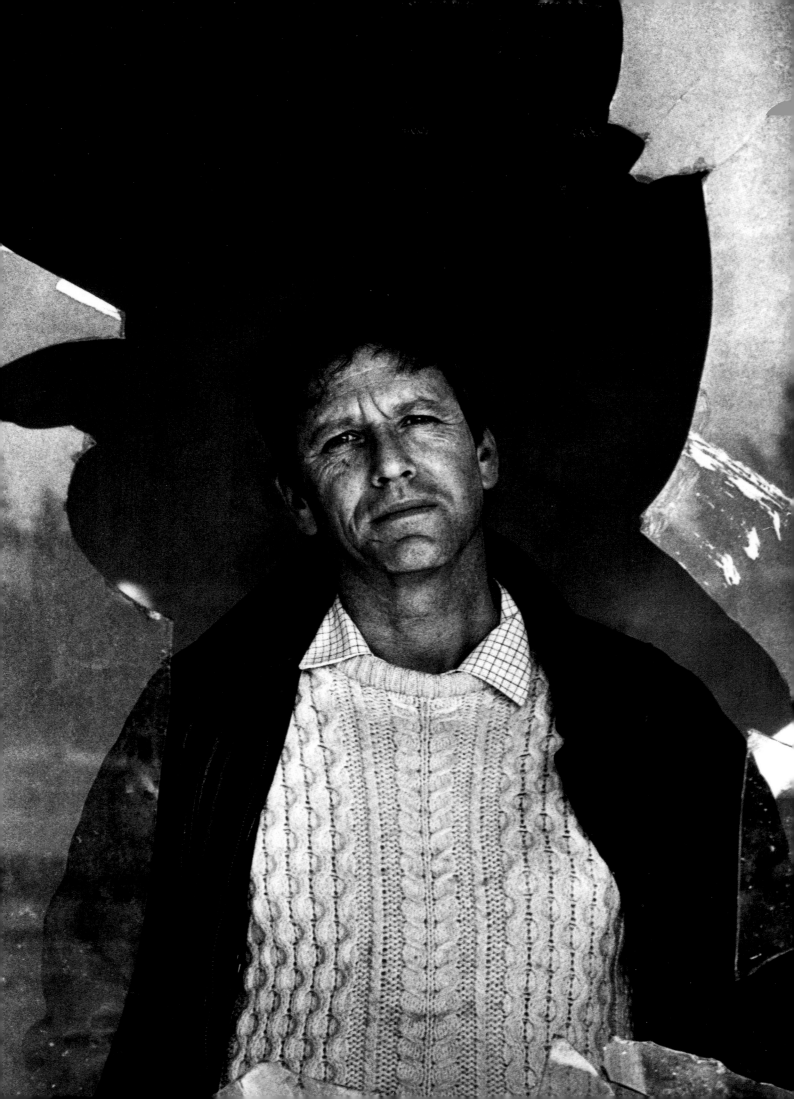

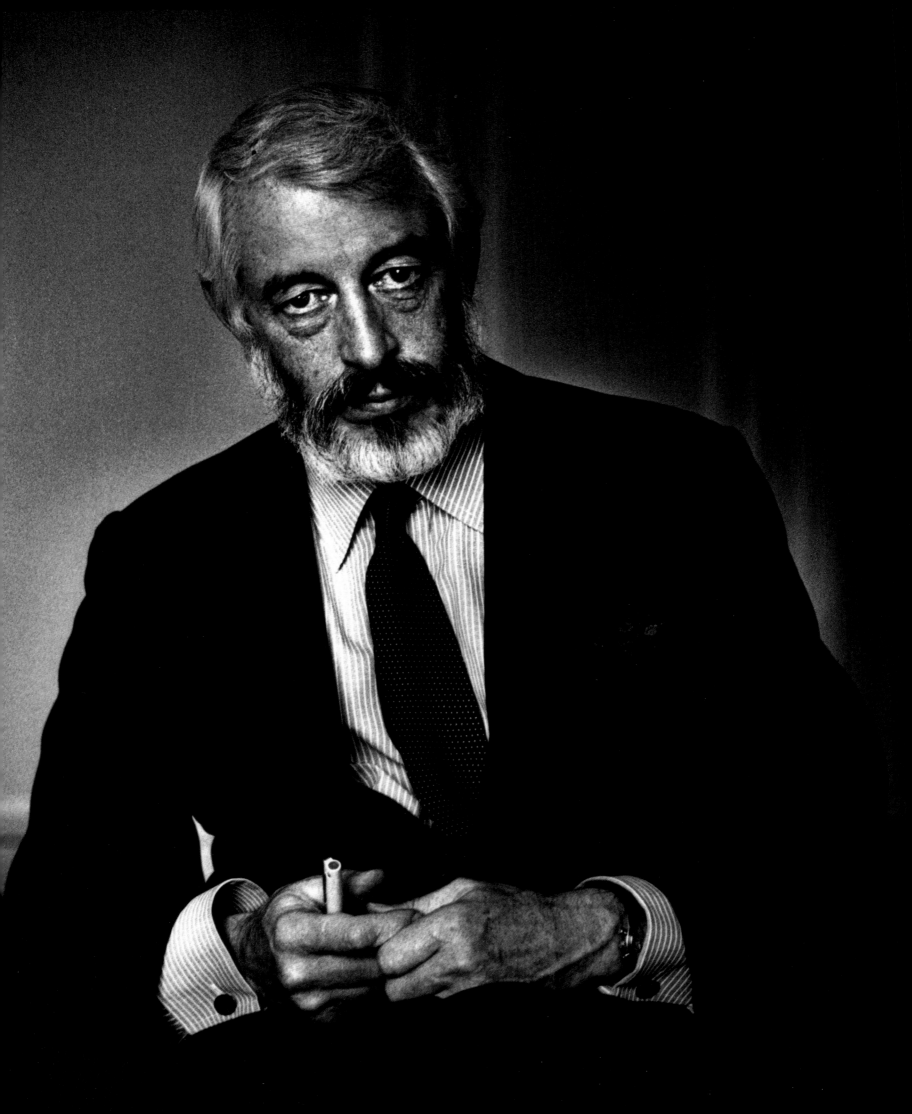

J P Donleavy 1986

The Beastly Beatitudes of Balthazar B

Stand here on Knightsbridge pavement
in the public domain. Where so much
of one's life began. To wait for a taxi to
take me just a little further away. Aboard
the train. Out of London and England.
Across the grey Channel. To bury a mother.
And chase others gone goodbye in my
years. Calling after their names. Come back
again. Where that countryside sings over
your grasses matted by wind and rains fall
in sunshine. Don't fear when some nights
rise up wild. Go walk in heather along
a narrow path. Seagulls glide and curlews
cry. Reach up and gather all this world.
Before dark or any other people should
ever come. And find you sheltering.
As all hearts are. Worried lonely. Your
eyes quiet. By the waters cold. Where the
sadness lurks so deep.

 It doth
 Make you
 Still

William Golding 1985

A Moving Target

More than a quarter of a century ago I sat
on one side of the fireplace and my wife
on the other. We had just put the children
to bed after reading to the elder some
adventure story or other – Coral Island,
Treasure Island, Coconut Island, Pirate
Island, Magic Island, God knows what
island. Islands have always and for
a good reason bulked large in the British
consciousness. But I was tired of these
islands with their paper-cutout goodies
and baddies and everything for the best
in the best of all possible worlds. I said
to my wife, 'Wouldn't it be a good idea
if I wrote a story about boys on an island
and let them behave the way they really
would?' She replied at once, 'That's a first
class idea. You write it.' So I sat down
and wrote it.

A story about boys, about people who
behave as they really would! What sheer
hubris! What an assumption of the divine
right of authors! How people really behave
– whole chapters in that row of books
behind my chair do little in the last
analysis but agree to or dissent from that
first casual remark. How then do I choose
a theme? Even then, did I know what I was
about? It had taken me more than half
a lifetime, two world wars and many years
among children before I could make that
casual remark because to me the job was
so plainly possible.

Yet there is something more. In a way
the book was to be and did become
a distillation from that life. Before the
Second World War my generation did on
the whole have a liberal and naive belief
in the perfectability of man. In the war
we became if not physically hardened at
least morally and inevitably coarsened.
After it we saw, little by little, what man
could do to man, what the Animal could
do to his own species. The years of my life
that went into the book were not years
of thinking but of feeling, years of wordless
brooding that brought me not so much
to an opinion as a stance. It was like
lamenting the lost childhood of the world.
The theme defeats structuralism for it is
an emotion. The theme of *Lord of the Flies*
is grief, sheer grief, grief, grief, grief.

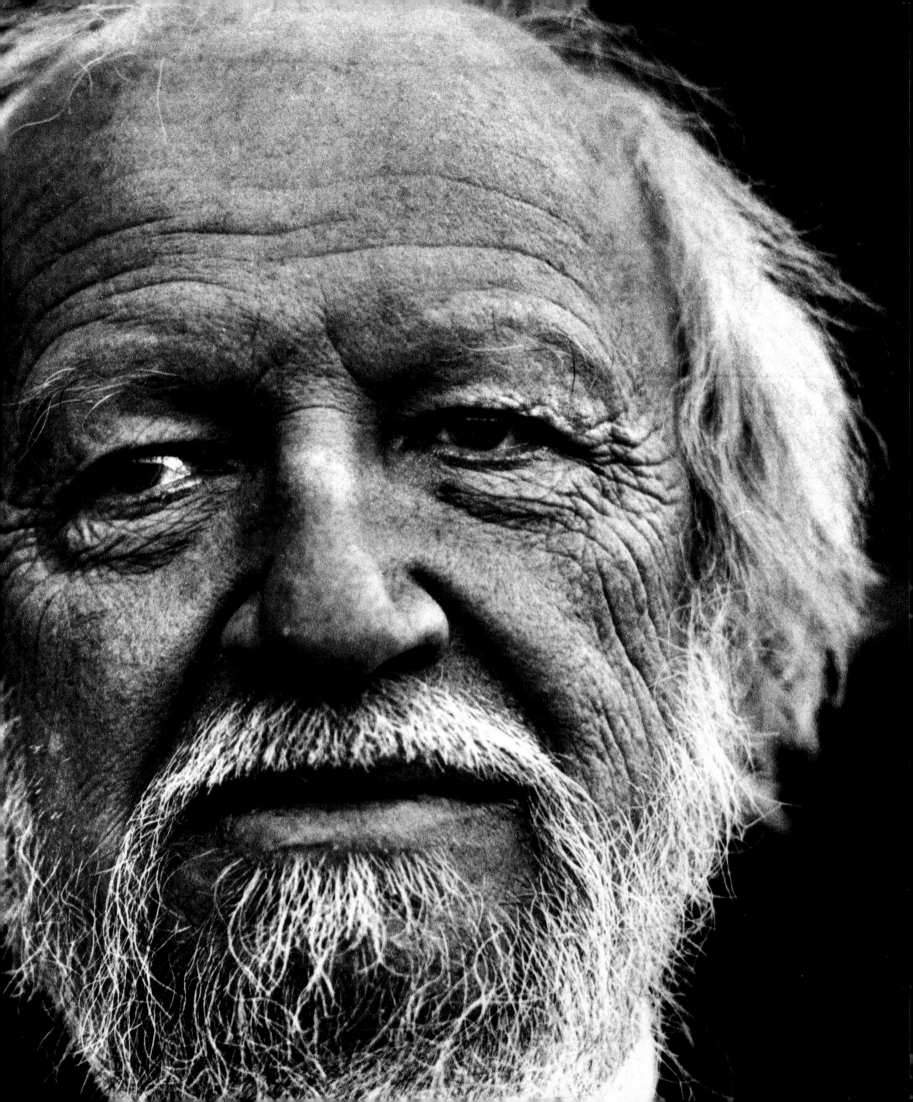

Advertisements for Myself

Like many another vain, empty and
bullying body of our time, I have been
running for President these last ten years
in the privacy of my mind, and it occurs
to me that I am less close now than
when I began. Defeat has left my nature
divided, my sense of timing is eccentric,
and I contain within myself the bitter
exhaustions of an old man, and the cocky
arguments of a bright boy. So I am
everything but my proper age of thirty-six,
and anger has brought me to the edge
of the brutal. In sitting down to write a
sermon for this collection, I find arrogance
in much of my mood. It cannot be helped.
The sour truth is that I am imprisoned with
a perception which will settle for nothing
less than making a revolution in the
consciousness of our time. Whether rightly
or wrongly, it is then obvious that I would
go so far as to think it is my present and
future work which will have the deepest
influence of any work being done by an
American novelist in these years. I could
be wrong, and if I am, then I'm the fool
who will pay the bill, but I think we can all
agree it would cheat this collection of its
true interest to present myself as more
modest than I am.

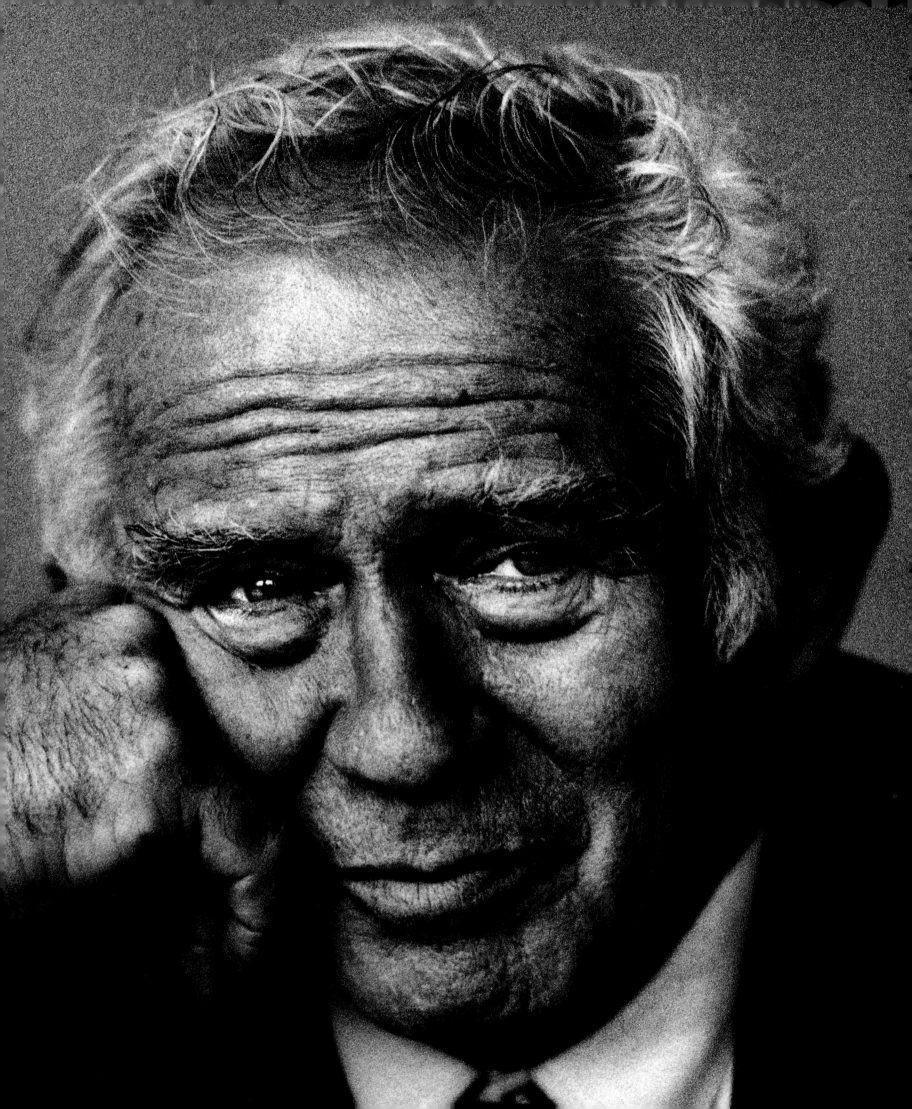

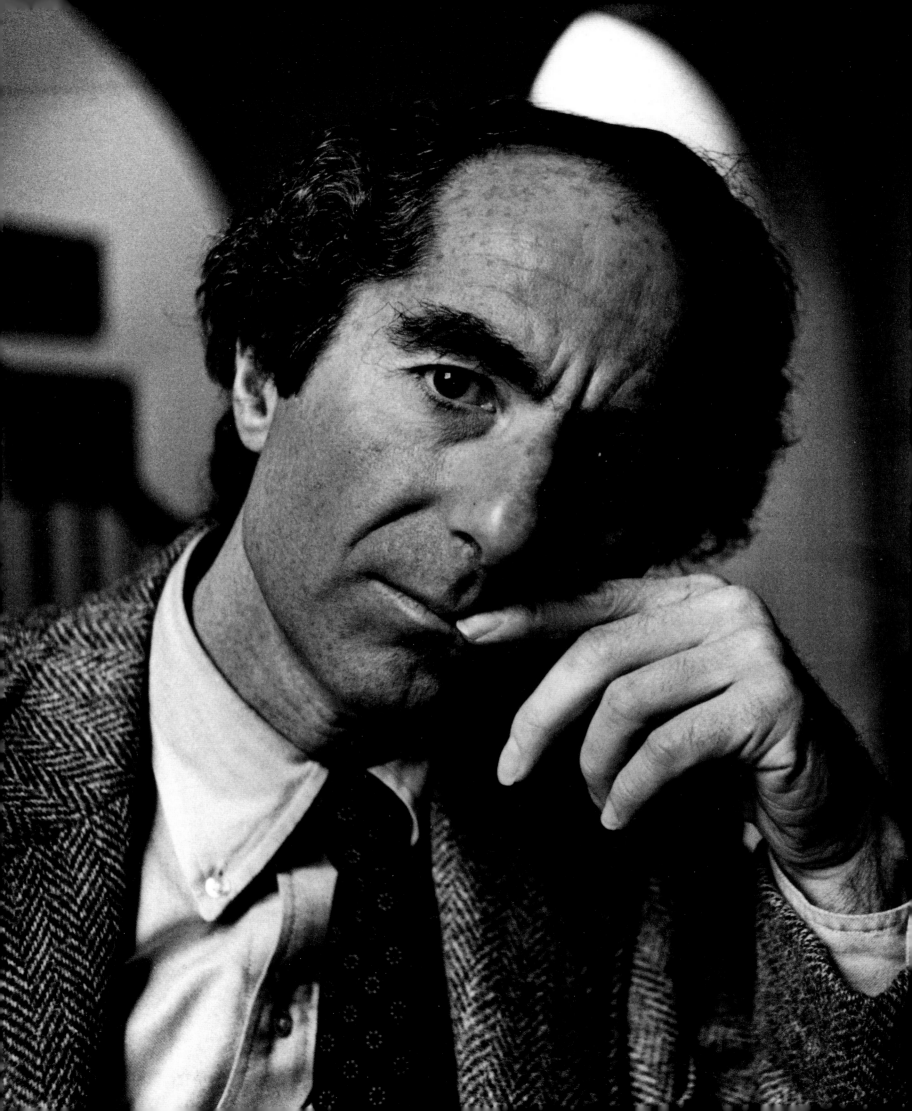

Philip Roth 1984

Deception

'I feel as though I don't have a cunt.
I left my cunt behind today. I don't want
to be reminded about it.'
'Okay.'
'You want me to go?'
'Hardly. You're near tears again today.'
'I do feel a bit teary, yes. Can I have
something to eat?'
'Well, there are some strawberries, and some
melons, and there's some bread,
and there's wine, and there's marijuana.'
'Can I have a little of each, please?'

Borges and I, by Jorge Luis Borges

The other one, the one called Borges,
is the one things happen to. I walk
through the streets of Buenos Aires
and stop for a moment, perhaps
mechanically now, to look at the arch
of an entrance hall and the grillwork
on the gate; I know of Borges from
the mail and see his name on a list of
professors or in a biographical dictionary.
I like hourglasses, maps, eighteenth-
century typography, the taste of coffee
and the prose of Stevenson; he shares
these preferences, but in a vain way that
turns them into the attributes of an actor.
It would be an exaggeration to say that
ours is a hostile relationship; I live, let
myself go on living, so that Borges may
contrive his literature, and this literature
justifies me. It is no effort for me to
confess that he has achieved some valid
pages, but those pages cannot save me,
perhaps because what is good belongs
to no one, not even to him, but rather to
the language and to tradition. Besides,
I am destined to perish, definitively, and
only some instant of myself can survive
in him. Little by little, I am giving over
everything to him, though I am quite
aware of his perverse custom of falsifying
and magnifying things. Spinoza knew that
all things long to persist in their being;
the stone eternally wants to be a stone and
the tiger a tiger. I shall remain in Borges,
not in myself (if it is true that I am
someone), but I recognise myself less in
his books than in many others or in the
laborious strumming of a guitar. Years ago
I tried to free myself from him and went
from the mythologies of the suburbs to
the games with time and infinity, but those
games belong to Borges now and I shall
have to imagine other things. Thus my
life is a flight and I lose everything and
everything belongs to oblivion, or to him.

I do not know which of us has written
this page.

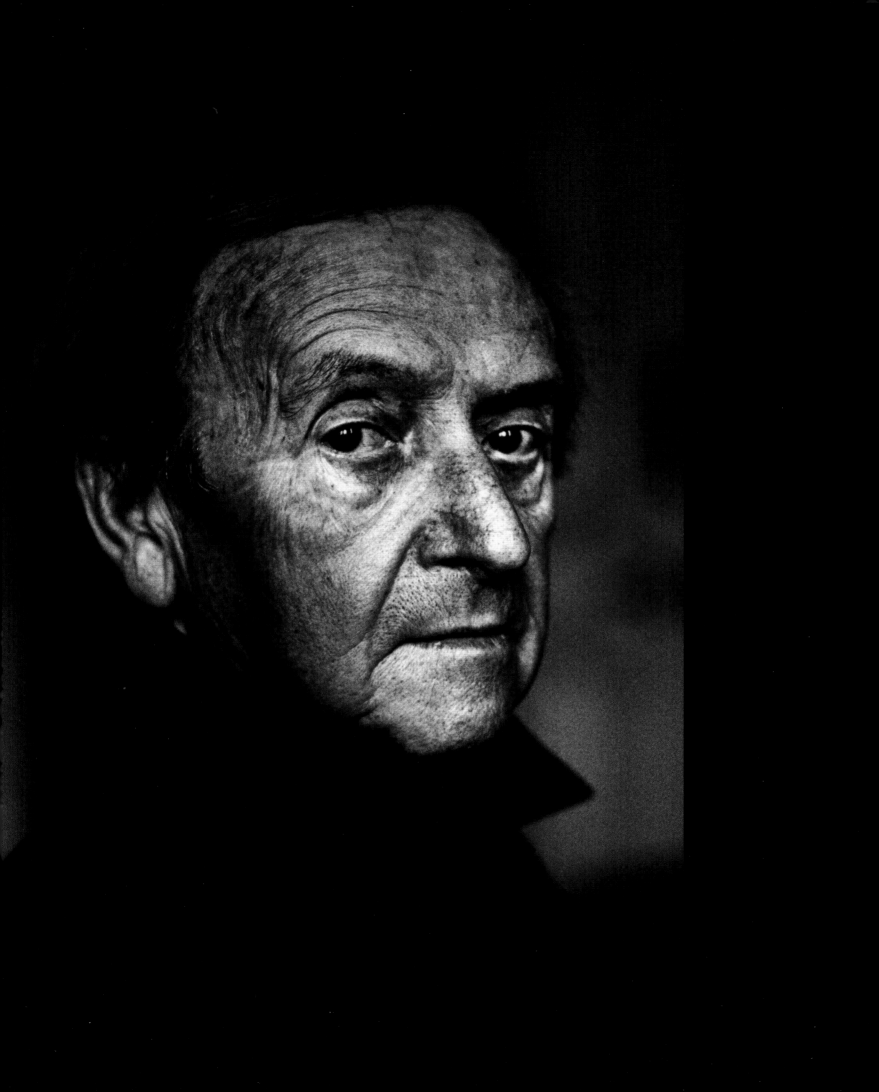

John Mortimer 1985

Clinging to the Wreckage

I walked into the house and felt that
I didn't own it and that I had no right
to move the books or rearrange the
furniture. We lit a fire and the chimney
smoked, we opened cupboards and drawers
feeling like intruders. I went into the
winter garden and thought of how it might
be put back in time to the day when I
planted a tree and met Penelope, to when
Henry Winter came to stay, to when I sat
beside my father's hammock and he swung
himself gently as I read him the Sherlock
Holmes stories which he already knew by
heart. So much of the garden had vanished
into the icy and tangled undergrowth that
I didn't know how it could be managed.

That is how it was, a part of life, seen from
one point of view. Much more happened
that I cannot tell or remember. To others it
would be, I am quite sure, a different story.
I have written all I can write about it now,
and these are the things that stayed with
me for a while, before they left to go
into a book.

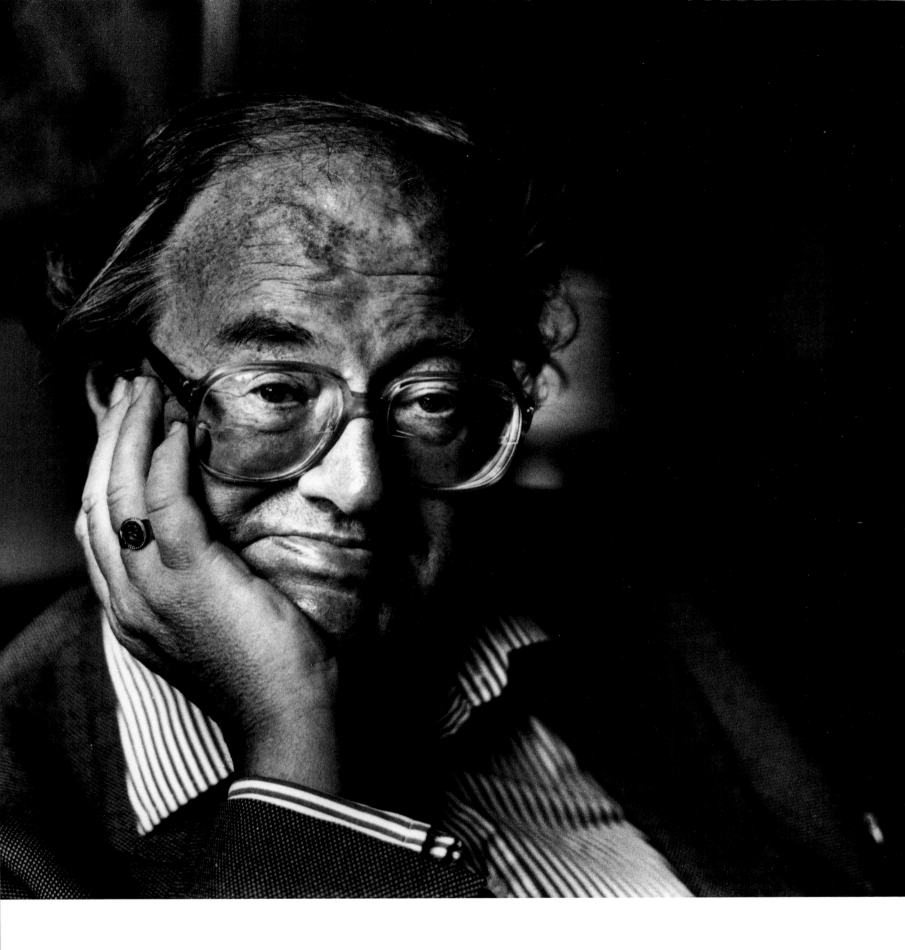

William Kennedy 1988

Ironweed

Riding up the winding road of Saint Agnes Cemetery in the back of the rattling old truck, Francis Phelan became aware that the dead, even more than the living, settled down in neighborhoods. The truck was suddenly surrounded by fields of monuments and cenotaphs of kindred design and striking size, all guarding the privileged dead. But the truck moved on and the limits of mere privilege became visible, for here now came the acres of truly prestigious death: illustrious men and women, captains of life without their diamonds, furs, carriages and limousines, but buried in pomp and glory, vaulted in great tombs built like heavenly safe-deposit boxes, or parts of the Acropolis. And ah yes, here too, inevitably, came the flowing masses, row upon row of them under simple headstones and simpler crosses. Here was the neighborhood of the Phelans.

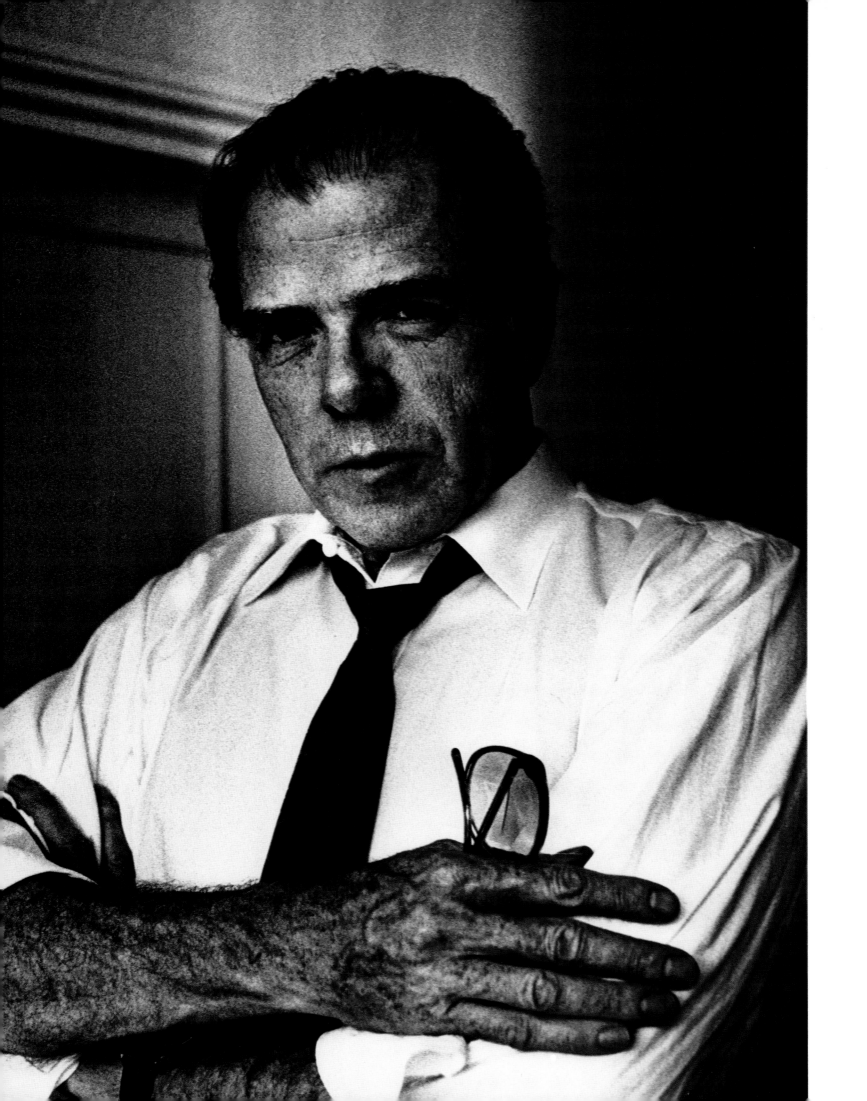

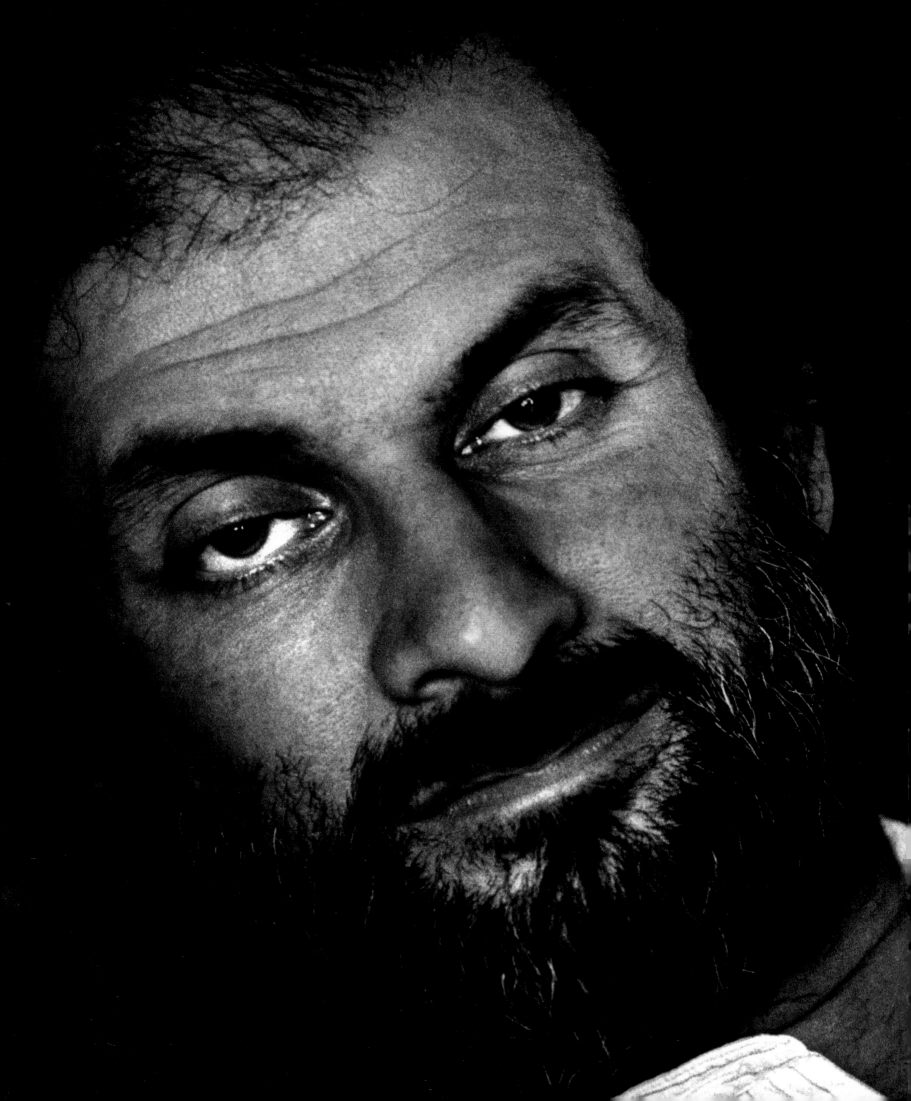

The Satanic Verses

Gibreel Farishta floating on his cloud formed the opinion that the moral fuzziness of the English was meteorologically induced. 'When the day is not warmer than the night,' he reasoned, 'when the light is not brighter than the dark, when the land is not drier than the sea, then clearly a people will lose the power to make distinctions, and commence to see everything – from political parties to sexual partners to religious beliefs – as much-the-same, nothing-to-choose, give-or-take. What folly! For truth is extreme, it is *so* and not *thus,* it is *him* and not *her;* a partisan matter, not a spectator sport, It is, in brief, *heated.* 'City,' he cried, and his voice rolled over the metropolis like thunder, 'I am going to tropicalize you.'

Giibreel enumerated the benefits of the proposed metamorphosis of London into a tropical city: increased moral definition, institution of a national siesta, development of vivid and expansive patterns of behaviour among the populace, higher-quality popular music, new birds in the trees (macaws, peacocks, cockatoos), new trees under the birds (coco-palms, tamarind, banyans with hanging beards). Improved street-life, outrageously coloured flowers (magenta, vermilion, neon-green), spider-monkeys in the oaks. A new mass-market for domestic air-conditioning units, ceiling fans, anti-mosquito coils and sprays. A coir and copra industry. Increased appeal of London as a centre for conferences, etc.; better cricketers; higher emphasis on ball-control among professional footballers, the traditional and soulless English commitment to 'high workrate' having been rendered obsolete by the heat. Religious fervour, political ferment, renewal of interest in the intelligentsia. No more British reserve; hot-water bottles to be banished for ever, replaced in the foetid nights by the making of slow and odorous love. Emergence of new social values: friends to commence dropping in on one another without making appointments, closures of old folks' homes, emphasis on the extended family. Spicier food; the use of water as well as paper in English toilets; the joy of running fully dressed through the first rains of the monsoon.

Disadvantages: cholera, typhoid, legionnaires' disease, cockroaches, dust, noise, a culture of excess.

Standing upon the horizon, spreading his arms to fill the sky, Gibreel cried: 'Let it be.'

The History Man

Now it is the autumn again; the people
are all coming back. The recess of summer
is over, when holidays are taken,
newspapers shrink, history itself seems
momentarily to falter and stop. But the
papers are thickening and filling again;
things seem to be happening; back from
Corfu and Sete, Positano and Leningrad,
the people are parking their cars and
campers in their drives, and opening
their diaries, and calling up other people
on the telephone. The deckchairs on the
beach have been put away, and a weak
sun shines on the promenade; there
is fresh fighting in Vietnam, while
McGovern campaigns ineffectually against
Nixon. In the chemists' shops in town,
they have removed the sunglasses and
the insect-bite lotions, for the summer
visitors have left, and have stocked
up on sleeping tablets and Librium, the
staples of the year-round trade; there
is direct rule in Ulster, and a gun-battle
has taken place in the Falls Road. The
new autumn colours are in the boutiques;
there is now on the market a fresh intra-
uterine device, reckoned to be ninety-nine
per cent safe. Everywhere there are
new developments, new indignities; the
intelligent people survey the autumn world,
and liberal and radical hackles rise, and
fresh faces are about, and the sun shines
fitfully, and the telephones ring. So,
sensing the climate, some people called
the Kirks, a well-known couple, decide
to have a party.

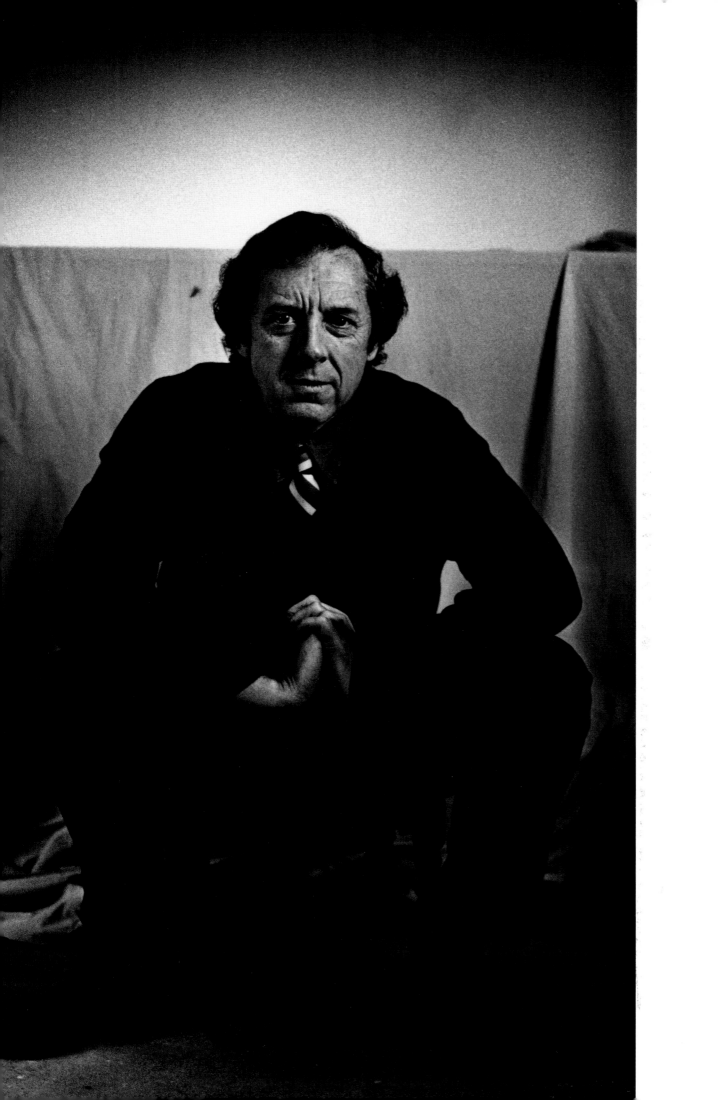

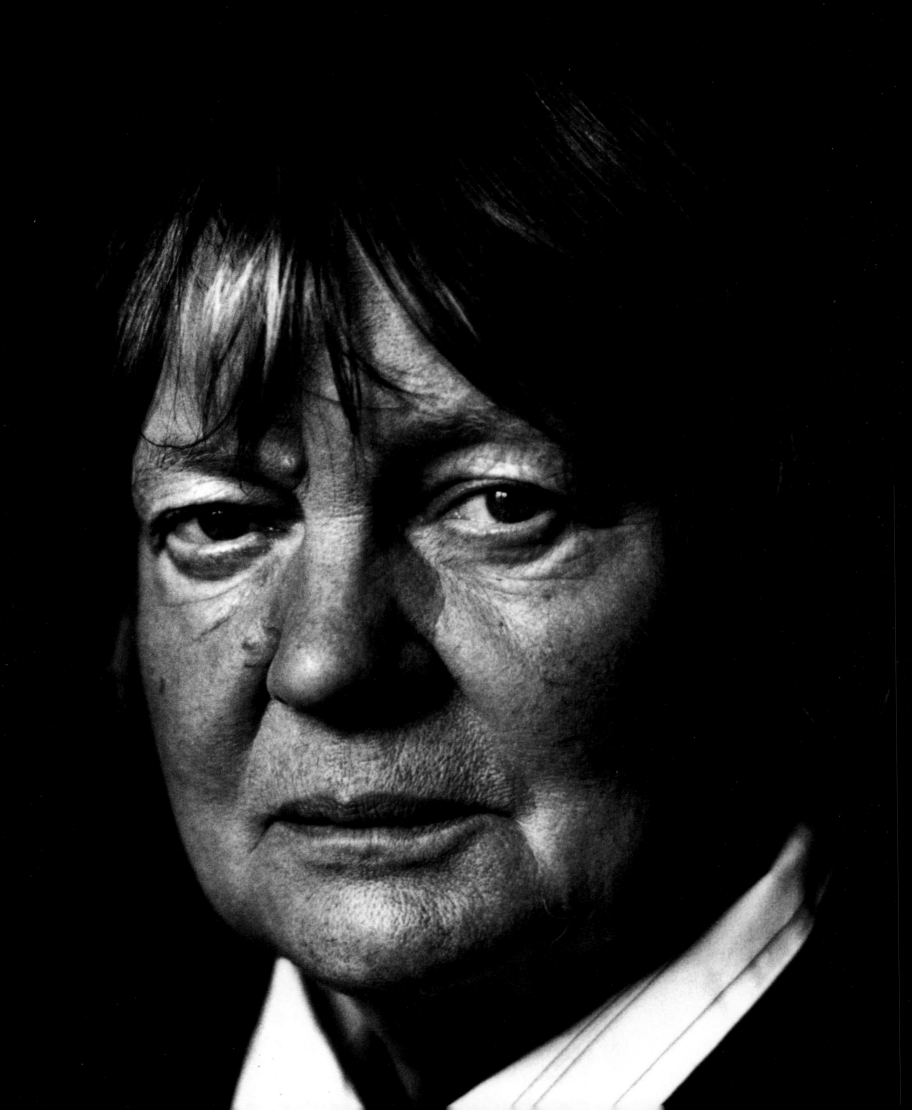

Iris Murdoch 1991

A Year of Birds

March

In dreadful light March evenings when the violets stain
And primrose pales the wood and trees are bare
And other happy birds do sing,
Our husky pairs of collared doves complain,
Never at ease.
Oh pretty lovers, does the spring
Now in your thoughtless blood so soon declare
That love is pain?

David Grossman 1991

See Under Love

Bruno Schulz had perceived that Munch
was a weak link, too. He'd guessed
as much long before, on finding
reproductions of *The Scream* in art
books back in Drohobycz. But seeing
the original with his own eyes convinced
him: Munch was a weak link, too. Like
Kafka and Mann and Dürer and Hogarth
and Goya and the others gracing his
notebook. A fragile network of weak links
across the world. Look after Munch. Look
after Bruno for his sake, for ours. Cherish
thine artist, but guard him well. Ring
him round with love, join hands and circle
him. Study his paintings. Cheer him.
Rejoice in his stories, but remember to
be shocked on occasion, and thank him for
his beautiful expression of blah-blah-blah,
and join hands around him to let him feel
your sympathy and your toughness, too,
and your iron-door-like impenetrability.
Spread your fingers while you clap,
suggesting prison bars, and always love
him, because that is the bargain; your
love for his prudence. His loyalty for
your aplomb.

Munch turned traitor. He allowed himself
to be unraveled, and the scream burst
rudely into your midst. And now it is here,
so quickly patch the hole. And they loved
Munch all the more! Gather round him
and let him feel your breath on his face:
he who failed once may fail again. Join
hands and cordon him off with a red sign
warning: DO NOT TOUCH.

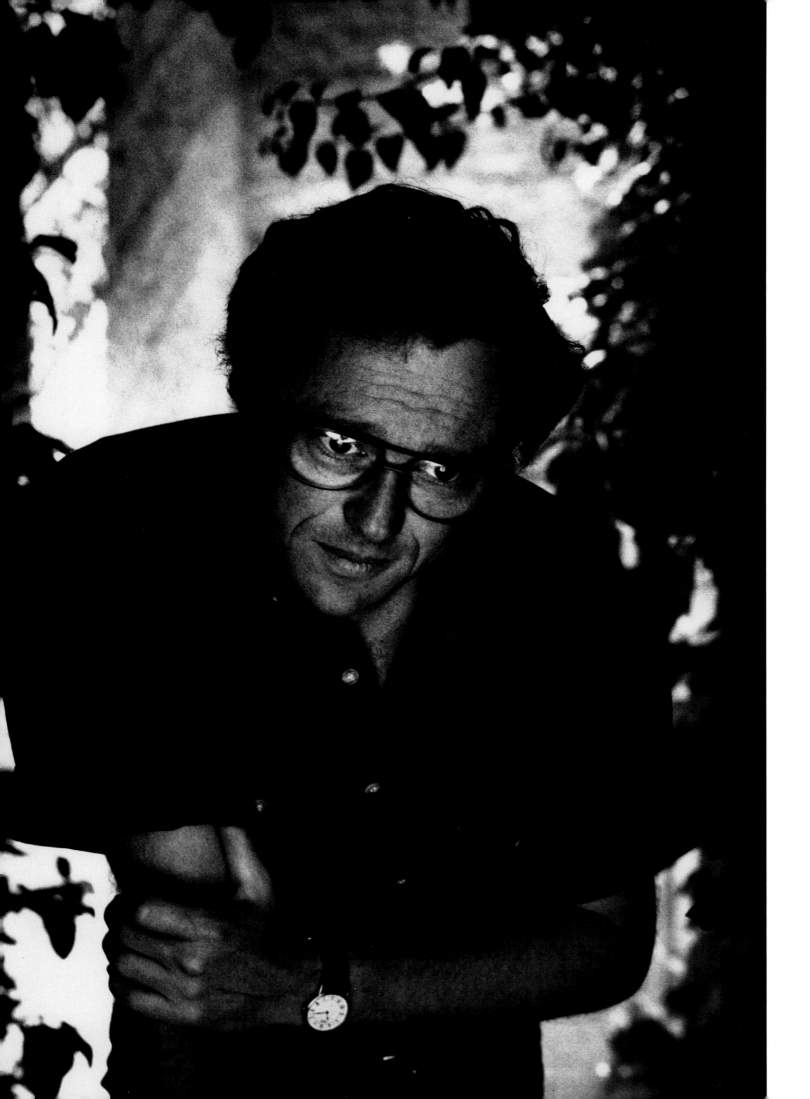

John Dollar

John, he dreams his father saying,
I've been thinking. Light has got to
have speed. It's obvious. Light travels.
People say, 'The stars bring tidings
of the future,' but I'm thinking. What
we call a star might only be its ghost.
At the very moment that we see it,
John: it might be *gone.*

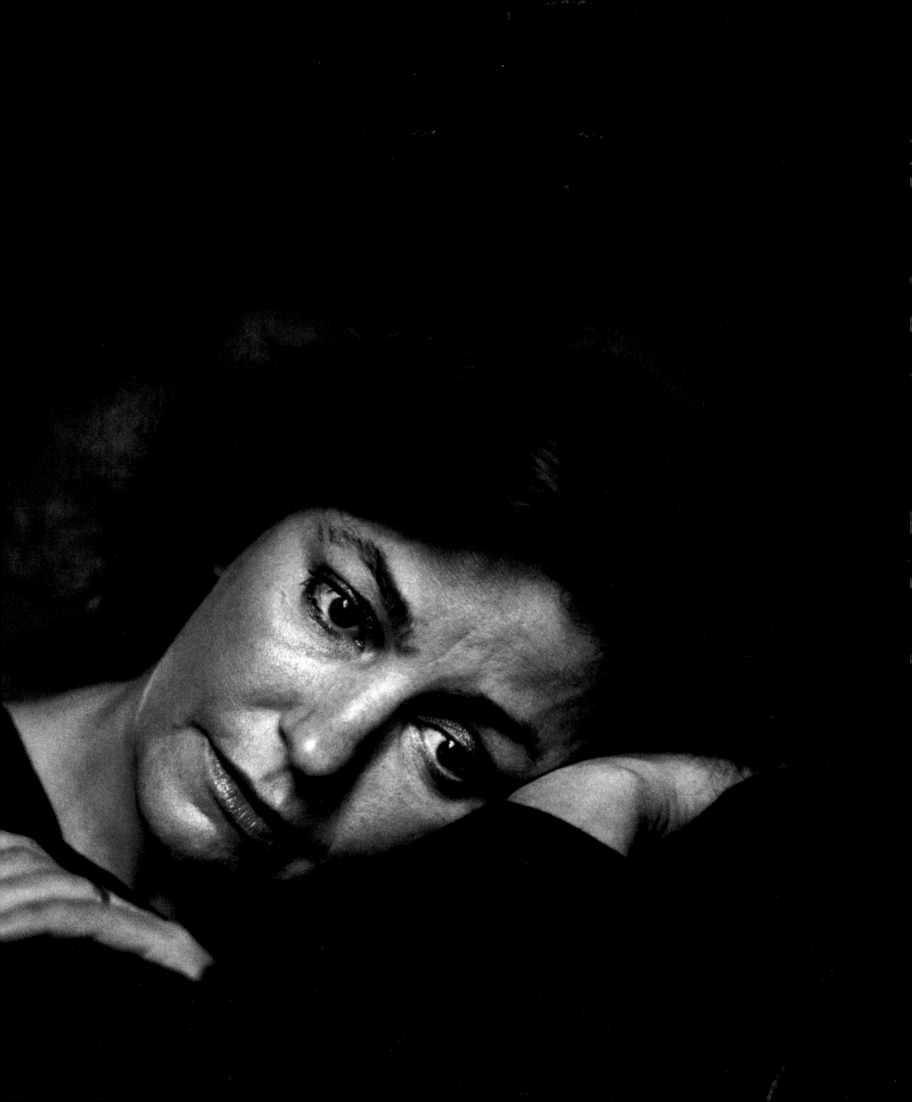

Bruce Chatwin 1987

In Patagonia

I walked along the esplanade and looked
out at the even line of cliffs spreading
round the bay, The cliffs were a lighter grey
than the grey of the sea and sky. The beach
was grey and littered with dead penguins.
Halfway along was a concrete monument
in memory of the Welsh. It looked like the
entrance to a bunker. Let into its sides were
bronze reliefs representing Barbarism and
Civilization. Barbarism showed a group of
Tehuelche Indians, naked, with slabby back
muscles in the Soviet style. The Welsh were
on the side of Civilization – greybeards,
young men with scythes, and big-breasted
girls with babies.

At dinner the waiter wore white gloves and
served a lump of burnt lamb that bounced
on the plate. Spread over the restaurant
wall was an immense canvas of gauchos
herding cattle into an orange sunset. An
old-fashioned blonde gave up on the lamb
and sat painting her nails. An Indian came
in drunk and drank through three jugs of
wine. His eyes were glittering slits in the
red leather shield of his face. The jugs were
of green plastic in the shape of penguins.

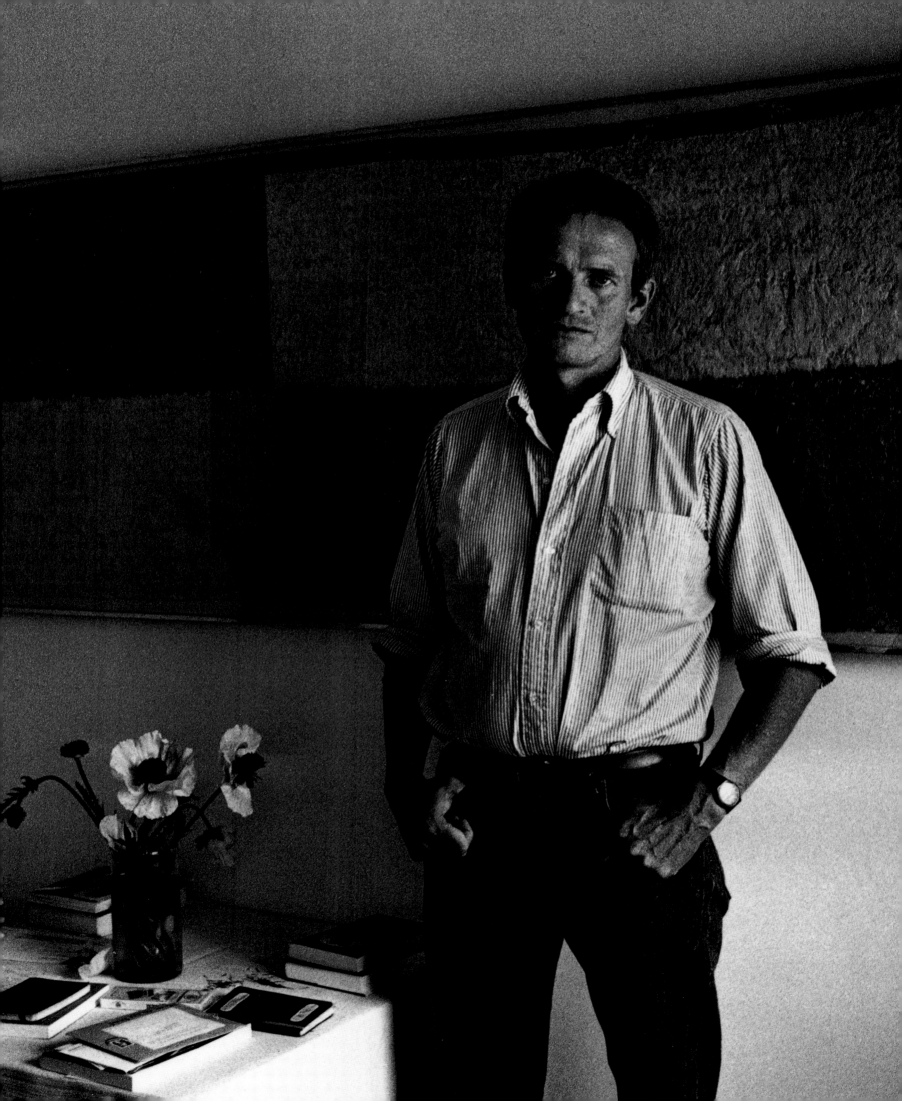

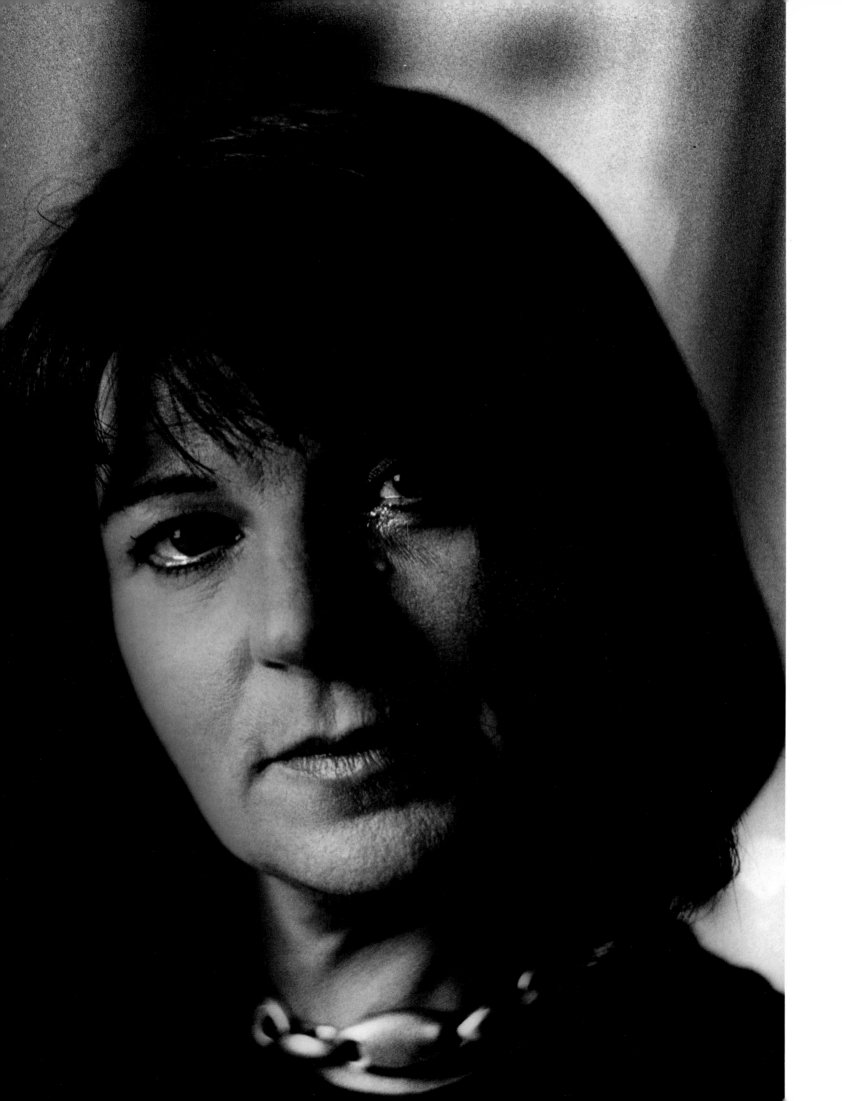

Josephine Hart 1992

Damage

There is an internal landscape, a geography
of the soul; we search for its outlines all
our lives.

Those who are lucky enough to find it
ease like water over a stone, onto its fluid
contours, and are home.

Some find it in the place of their birth;
others may leave a seaside town, parched,
and find themselves refreshed in the
desert. There are those born in rolling
countryside who are really only at ease in
the intense and busy loneliness of the city.

For some, the search is for the imprint of
another; a child or a mother, a grandfather
or a brother, a lover, a husband, a wife,
or a foe.

We may go through our lives happy or
unhappy, successful or unfulfilled, loved
or unloved, without ever standing cold
with the shock of recognition, without
ever feeling the agony as the twisted iron
in our soul unlocks itself and we slip at
last into place.

A Season in the West

She went back to her own desk and at once
wrote a note to Birek in the style in which
she thought such notes were written:

'My darling. I can hardly bear to write
this – I couldn't say it on Thursday – but
I cannot come and see you like that any
more. I still love and respect you as much
as I always did, but I can no longer bear
the thought that in loving you I am
betraying others. Please forgive me and
in time come to think of me as your very,
very best friend. L.'

She read it over quickly, afraid that
Miroslav Maier might come up behind her.
She wondered whether it was prudent to
admit in writing that he had been her lover,
but could not be bothered to re-write
the letter so she put it in an envelope and
sealed it. She then took her purse from
her bag to find a stamp – she could hardly
trust it to the office franking machine –
and dithered between a first-class and
a second-class stamp. Then deciding that
it must reach him before the day he was
expecting to see her again, she licked
a first-class stamp and stuck it on the
envelope, thinking as she did so one
of those ignoble little thoughts which
she immediately regretted – that the 18p
was the very last sum of money that she
would ever spend on Josef Birek.

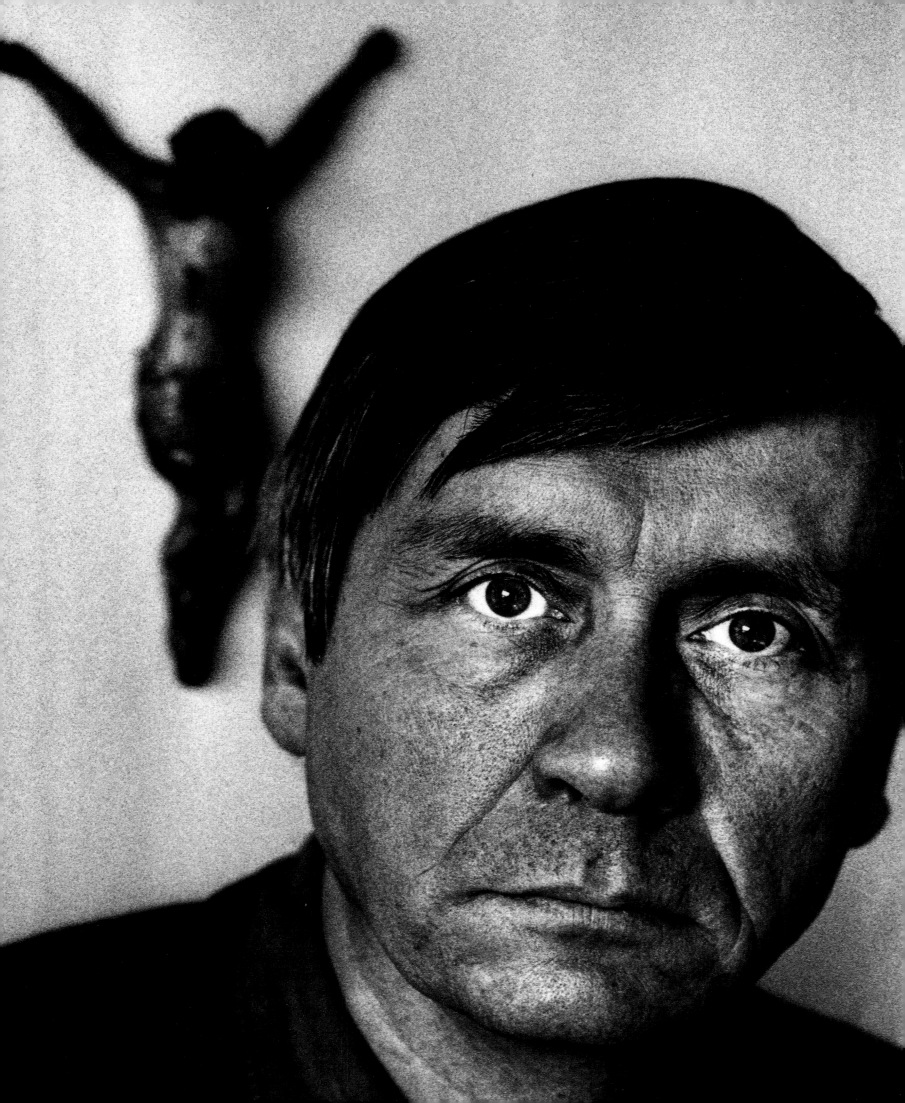

Alison Lurie 1988

Real People

The only reason for writing fiction
at all is to combine a number of different
observations at the point where they
overlap. If you already have one perfect
example ... you might as well write
nonfiction. Indeed, you should ...

But ordinarily you don't have a single
perfect example. Instead, over the years
you've noticed, say, something about
the way children behave at their own
birthday parties, but none of your
examples is complete in itself. So you
invent a children's party which never
took place, but is 'realer' in the Platonic
sense than any you ever attended. Fiction
is condensed reality; and that's why its
flavor is more intense, like bouillon
or frozen orange juice.

Simon Schama 1992

The Leopard, by Giuseppe di Lampedusa

Still she could feel nothing; the inner
emptiness was complete; but she did
sense an unpleasant atmosphere exhaling
from the heap of furs. That was to-day's
distress: even poor Bendicò was hinting
at bitter memories. She rang the bell.
'Annetta,' she said. 'This dog has really
become too moth-eaten and dusty. Take
it out and throw it away.'

As the carcass was dragged off, the
glass eyes stared at her with the humble
reproach of things that are thrown away,
got rid of. A few minutes later what
remained of Bendicò was flung into
a corner of the courtyard visited every
day by the dustman. During the flight
down from the window its form recomposed
itself for an instant; in the air there
seemed to be dancing a quadruped with
long whiskers, its right foreleg raised
in imprecation. Then all found peace
in a heap of livid dust.

Vikram Seth 1993

All You Who Sleep Tonight

All you who sleep tonight
Far from the ones you love,
No hand to left or right,
And emptiness above –

Know that you aren't alone.
The whole world shares your tears,
Some for two nights or one,
And some for all their years.

Kazuo Ishiguro 1989

The Remains of the Day

It is sometimes said that butlers only
truly exist in England. Other countries,
whatever title is actually used, have only
manservants. I tend to believe this is true.
Continentals are unable to be butlers
because they are as a breed incapable
of the emotional restraint which only the
English race is capable of. Continentals –
and by and large the Celts, as you will
no doubt agree – are as a rule unable
to control themselves in moments of strong
emotion, and are thus unable to maintain
a professional demeanour other than in
the least challenging of situations. If I may
return to my earlier metaphor – you will
excuse my putting it so coarsely – they
are like a man who will, at the slightest
provocation, tear off his suit and his
shirt and run about screaming. In a word,
'dignity' is beyond such persons. We
English have an important advantage over
foreigners in this repsect and it is for this
reason that when you think of a great
butler, he is bound, almost by definition,
to be an Englishman.

David Lodge 1988

How Far Can You Go

So they stood upon the shores of Faith
and felt the old dogmas and certainties
ebbing away rapidly under their feet
and between their toes, sapping the
foundations upon which they stood,
a sensation both agreeably stimulating
and slightly unnerving. For we all like
to believe, do we not, if only in stories?
People who find religious belief absurd
are often upset if a novelist breaks the
illusion of reality he has created. Our
friends had started life with too many
beliefs – the penalty of a Catholic
upbringing. They were weighed down
with beliefs, useless answers to non-
questions. To work their way back to the
fundamental ones – what can we know?
why is there anything at all? why not
nothing? what may we hope? why are
we here? what is it all about? – they
had to dismantle all that apparatus
of superfluous belief and discard it piece
by piece. But in matters of belief (as of
literary convention) it is a nice question
how far you can go in this process
without throwing out something vital.

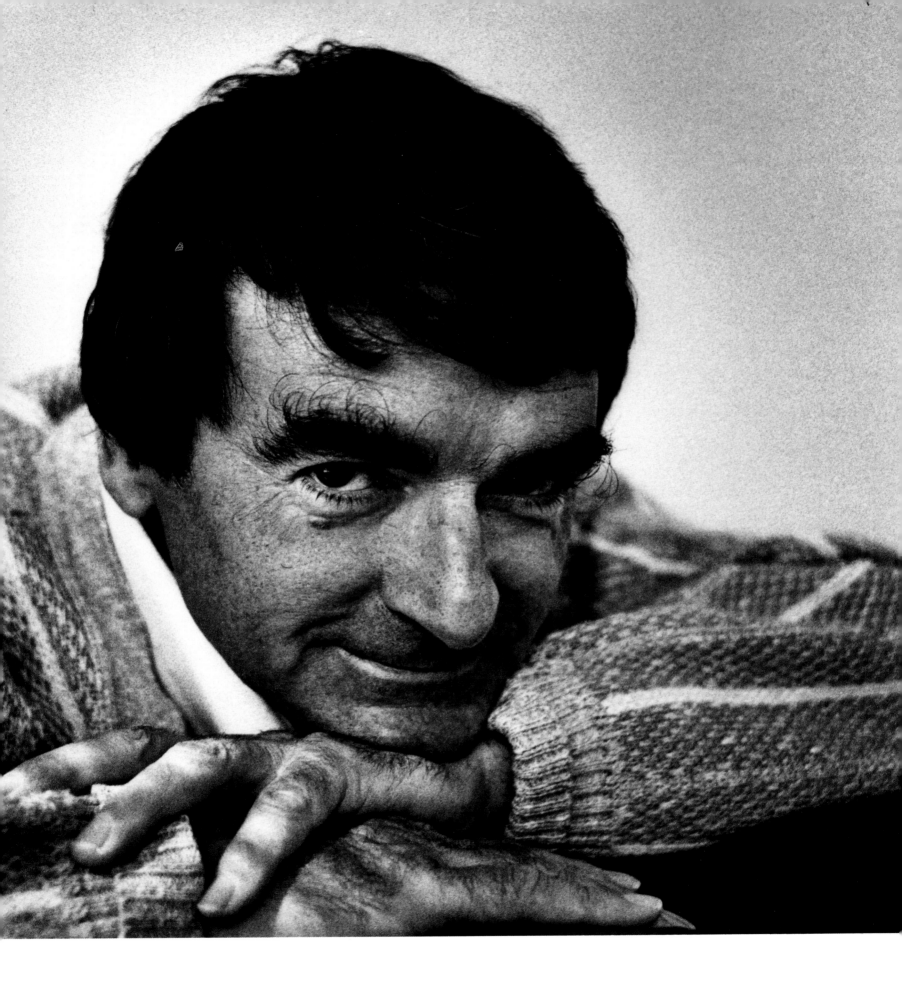

John Updike 1991

Self-Consciousness (Memoirs, 1989)

It has snowed during the night; through
the window, as I rise to dress and shave,
I see an inch or two of snow on the still-
green lawn, and on the boughs of the pine
tree holding the bird feeder. In this low-
ceilinged room the light is antique,
preserved from the Philadelphia Avenue
house, my first tender winters in it, with
their evergreen secret of Christmas. The
light holds my first inklings of celebration,
of reindeer tracks on the roof, of an
embowering wide world arranged for my
mystification and entertainment. It has
the eggshell tint, the chilly thrilling taste,
of my self.

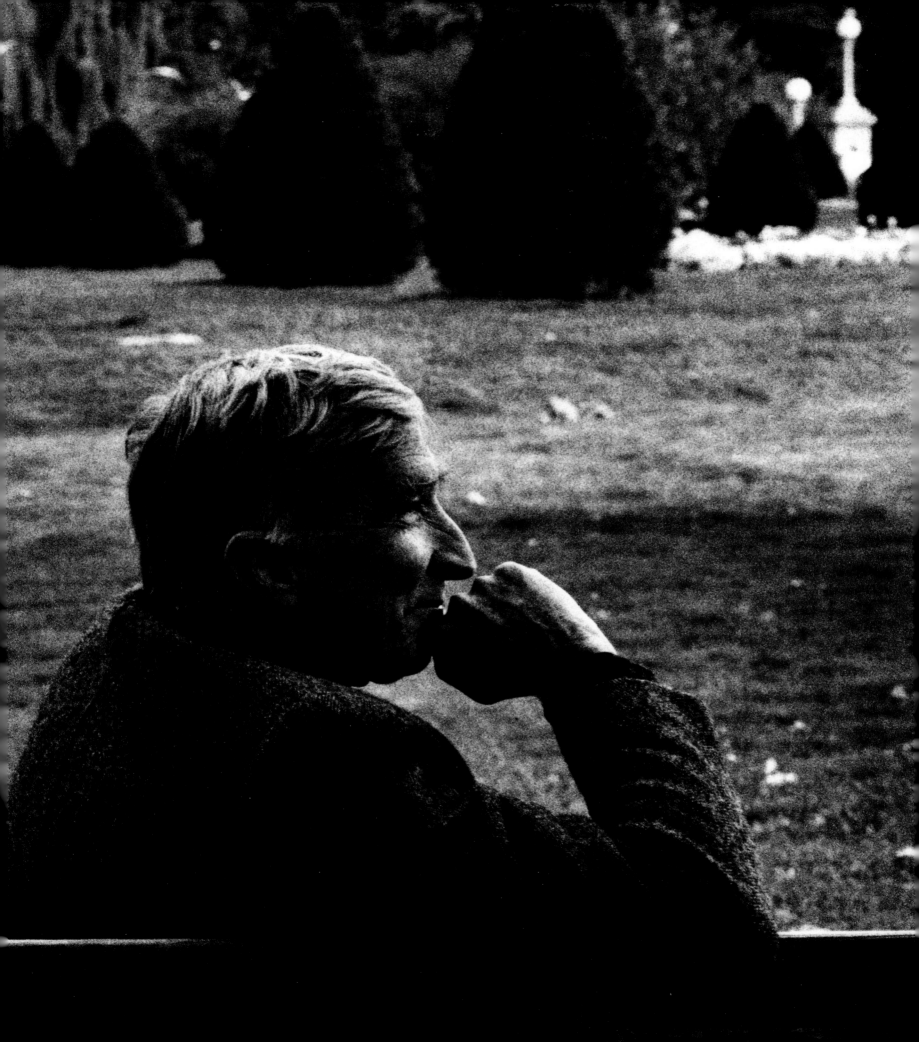

Angela Carter 1981

Expletives Deleted

I spent a good many years being told what
I ought to think, and how I ought to
behave, and how I ought to write, even,
because I was a woman and men thought
they had the right to tell me how to feel,
but then I stopped listening to them and
tried to figure it out for myself, but they
didn't stop talking, oh, dear no. So I
started answering back. How simple, not
to say simplistic, this all sounds; and
yet it is true.

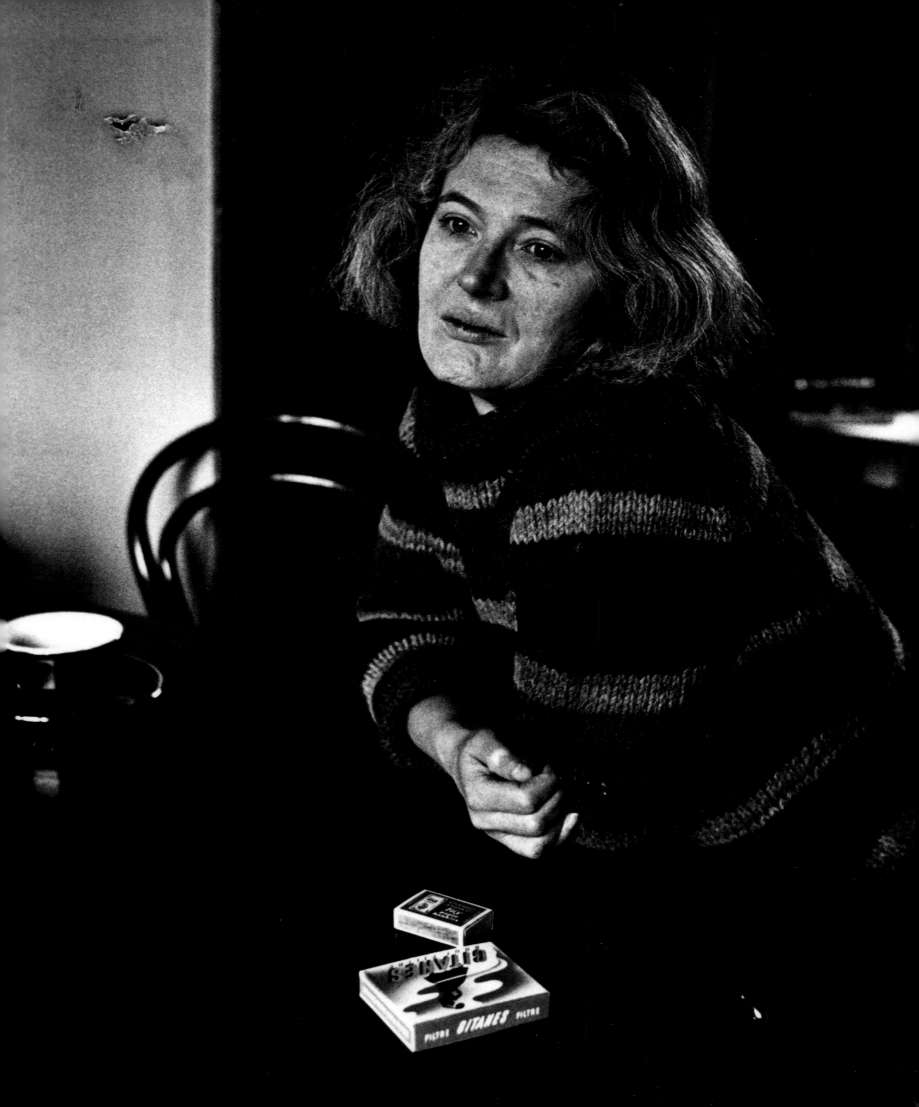

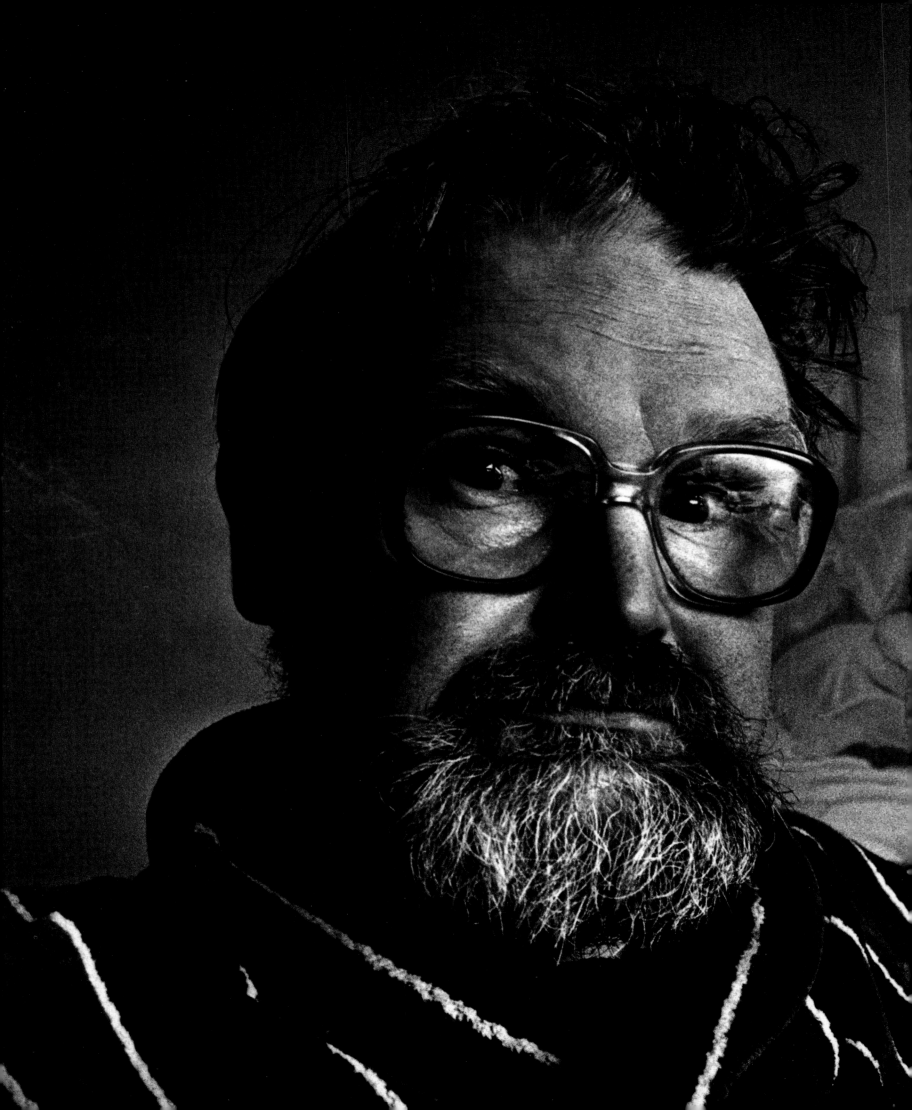

Alasdair Gray 1990

Economy

In weather like this the homeless can hardly live
and every year makes more of them, none of them me.
I give to beggars of course, though charity
prolongs their pain. So do market forces.

Strong brains who tackle problems of this kind
need the protection of a cosy house
or several. I manage with only two,
and love these cold grey rainy Glasgow streets
at home in bed here, holding and held by you.

Ruth Rendell 1993

Iron in the Soul, by Jean-Paul Sartre

No, he thought, no, it isn't heads or tails.
Whatever happens it is by my agency that
it must happen. Even if he let himself
be carried off like an old sack of coal, he
would have chosen his own damnation;
he was free, free in every way, free to
behave like a fool or a machine, free to
accept, free to refuse, free to equivocate ...
He could do what he liked, no one had the
right to advise him, there would be for him
no good nor evil unless he brought them
into being. All around him things were
gathered in a circle, expectant, impassive
and indicative of nothing. He was alone,
enveloped in this monstrous silence, free
and alone, without assistance and without
excuse, condemned to decide without
support from any quarter, condemned for
ever to be free.

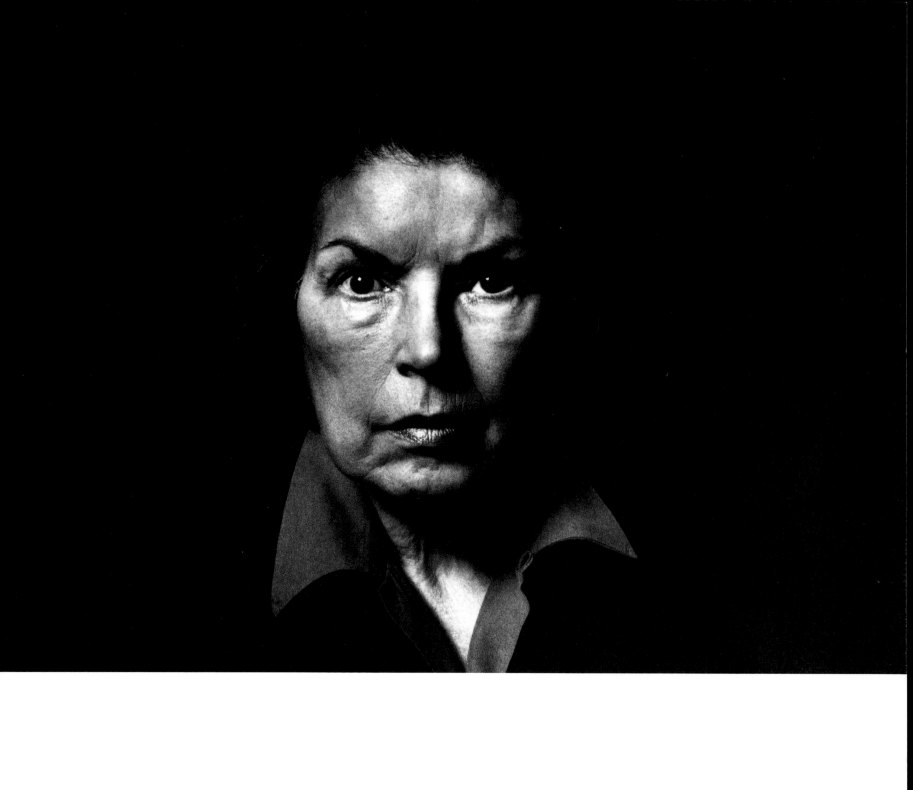

Saul Bellow 1992

Something To Remember Me By

It began like any other winter school day in
Chicago – grimly ordinary. The temperature
a few degrees above zero, botanical frost
shapes on the windowpane, the snow swept
up in heaps, the ice gritty and the streets,
block after block, bound together by the
iron of the sky. A breakfast of porridge,
toast, and tea. Late as usual, I stopped
for a moment to look into my mother's
sickroom. I bent near and said, 'It's Louie,
going to school.' She seemed to nod. Her
eyelids were brown; the color of her face
was much lighter. I hurried off with my
books on a strap over my shoulder.

When I came to the boulevard on the
edge of the park, two small men rushed out
of a doorway with rifles, wheeled around
aiming upward, and fired at pigeons near
the rooftop. Several birds fell straight
down, and the men scooped up the soft
bodies and ran indoors, dark little guys
in fluttering white shirts. Depression
hunters and their city game. Moments
before, the police car had loafed by at ten
miles an hour. The men had waited it out.

This had nothing to do with me. I mention
it merely because it happened. I stepped
around the blood spots and crossed into
the park.

Richard Ford 1991

Wildlife

And then at the end of the March, in 1961,
just as it was beginning to be spring, my
mother came back from wherever she had
been. In a while she and my father found
a way to settle the difficulties that had
been between them. And though they may
both have felt that something had died
between them, something they may not
even have been aware of until it was gone
and disappeared from their lives forever,
they must've felt – both of them – that
there was something of themselves,
something important, that could not live
at all in any other way but by their being
together, much as they had been before.
I do not know exactly what that something
was. But that is how our life resumed after
then, for the little time that I was at home.
And for many years after that. They lived
together – that was their life – and alone.
Though God knows there is still much to
it that I myself, their only son, cannot
fully claim to understand.

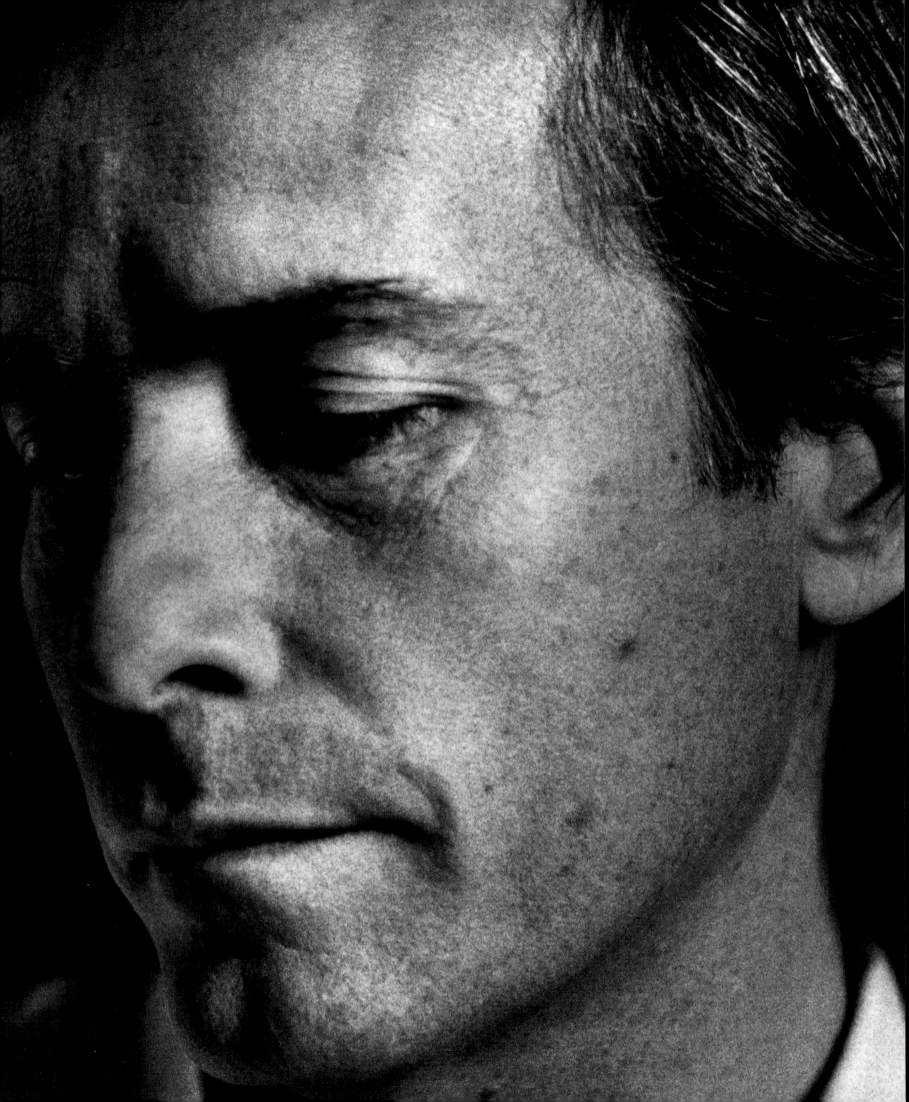

The Shooting Party

'It caused a mild scandal at the time, but
in most people's memories it was quite
outshone by what succeeded it. You could
see it as a drama all played out in a room
lit by gas lamps; perhaps with flickering
sidelights thrown by a log fire burning
brightly at one side of the room, a big
Edwardian drawing-room, full of furniture,
tables crowded with knick-knacks and
framed photographs, people sitting or
standing in groups, conversing; and then
a fierce electric light thrown back from
a room beyond, the next room, into which
no one has yet ventured, and this fierce
retrospective light through the doorway
makes the lamplit room seem shadowy,
the flickering flames in the grate pallid,
the circles of yellow light round the lamps
opaque (a kind of tarnished gold) and the
people, well, discernibly people, but people
from a long time ago, our parents and
grandparents made to seem like beings
from a much remoter past, Charlemagne
and his knights or the seven sleepers half
aroused from their thousand year sleep.

It was an error of judgment which resulted
in a death. It took place in the autumn
before the outbreak of what used to be
known as the Great War.'

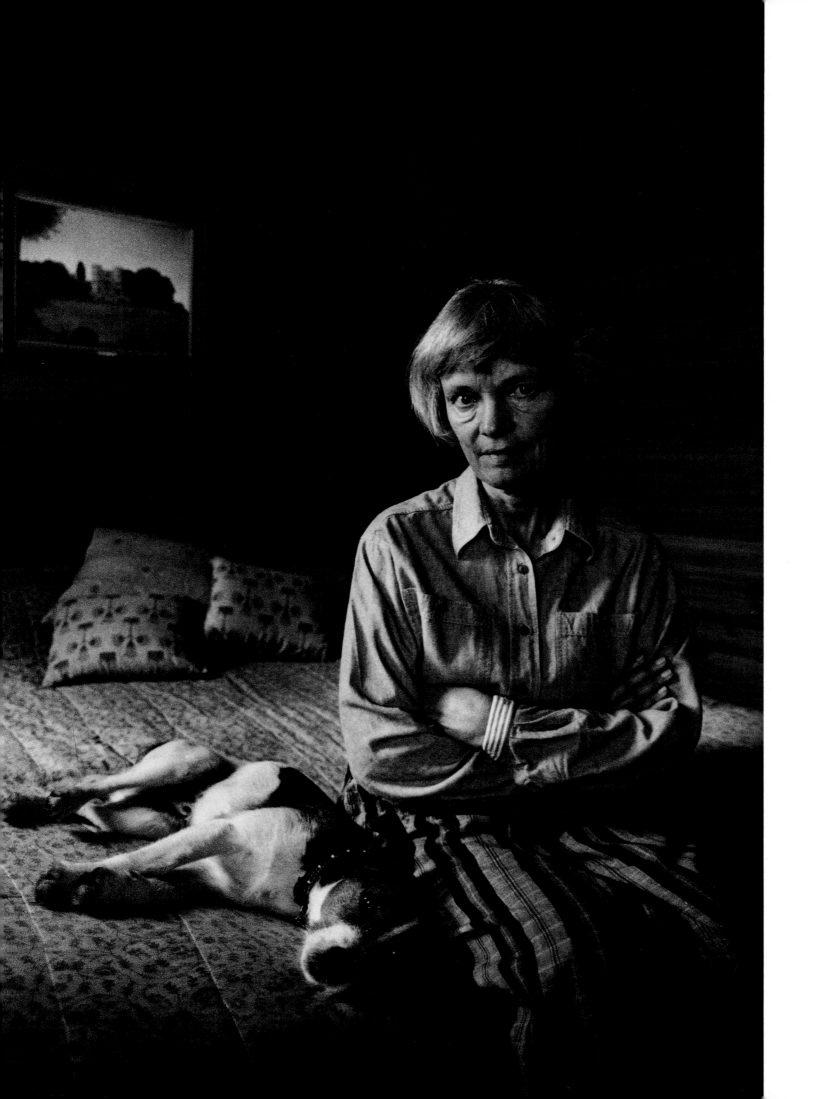

Stephen Spender 1988

World Within World

I remember the winter evenings with the
heavy curtains drawn, and, spread over the
table, the exciting paint-boxes and paper
which called images into being. My mother
perhaps wore that amethyst necklace of
transparent golden stones (it belongs
now to my wife) which I associate with
the nearness of her neck when she leaned
down to kiss me at night. On one such
evening, while she was painting a poster,
she stopped working, sighed deeply and
said: 'This terrible war.' That remark
provoked me to repeat what I had read
that morning in my school history book:
'The most terrible war of all time was that
of the English against Joan of Arc.' 'This
is the most terrible war that has been,'
she exclaimed with harsh anguish. The
next day I learned that our uncle, Alfred
Schuster, had been killed.

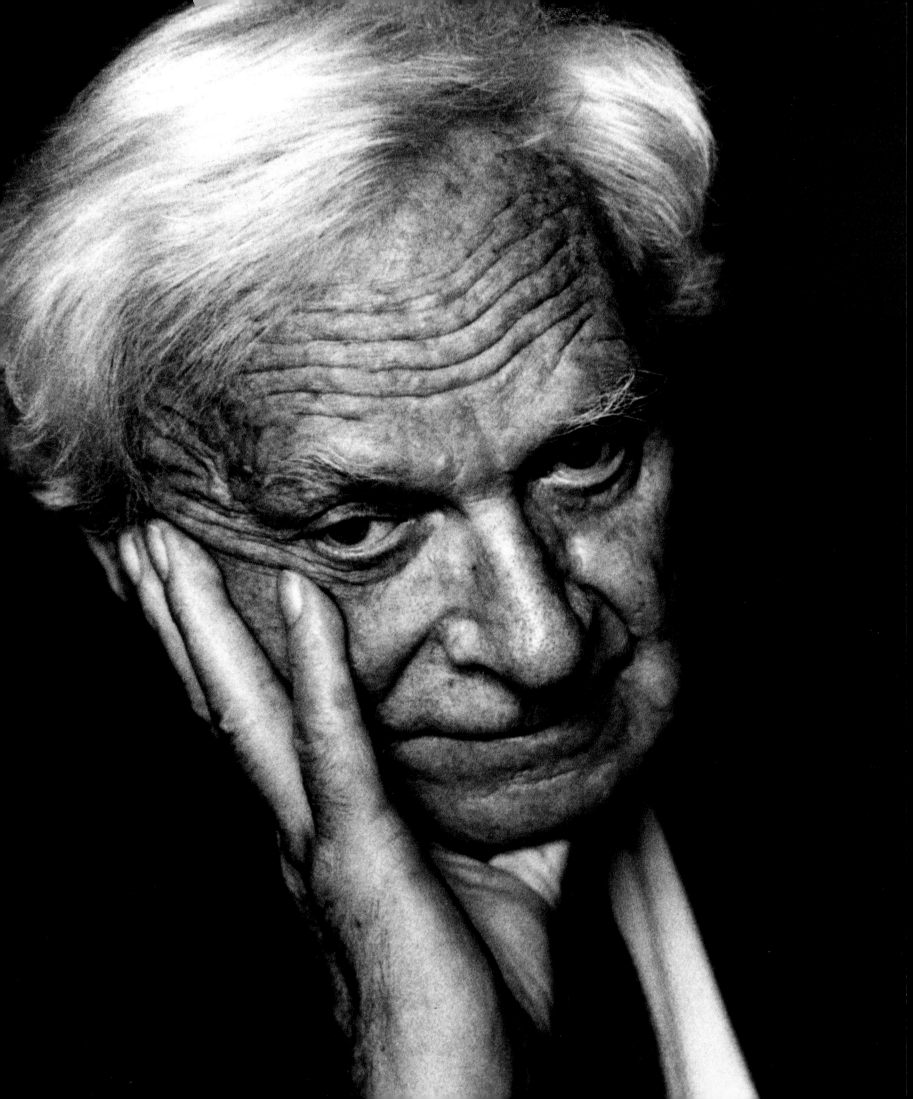

The Locked Room

'In a book I once read by Peter Freuchen,' Fanshawe writes, 'the famous Arctic explorer describes being trapped by a blizzard in northern Greenland. Alone, his supplies dwindling, he decided to build an igloo and wait out the storm. Many days passed. Afraid, above all, that he would be attacked by wolves – for he heard them prowling hungrily on the roof of his igloo – he would periodically step outside and sing at the top of his lungs in order to frighten them away. But the wind was blowing fiercely, and no matter how hard he sang, the only thing he could hear was the wind. If this was a serious problem, however, the problem of the igloo itself was much greater. For Freuchen began to notice that the walls of his little shelter were gradually closing in on him. Because of the particular weather conditions outside, his breath was literally freezing to the walls, and with each breath the walls became that much thicker, the igloo became that much smaller, until eventually there was almost no room left for his body. It is surely a frightening thing, to imagine breathing yourself into a coffin of ice, and to my mind considerably more compelling than, say, *The Pit and the Pendulum* by Poe. For in this case it is the man himself who is the agent of his own destruction, and further, the instrument of that destruction is the very thing he needs to keep himself alive. For surely a man cannot live if he does not breathe. But at the same time, he will not live if he does breathe. Curiously, I do not remember how Freuchen managed to escape his predicament. But needless to say, he did escape. The title of the book, if I recall, is *Arctic Adventure*. It has been out of print for many years.'

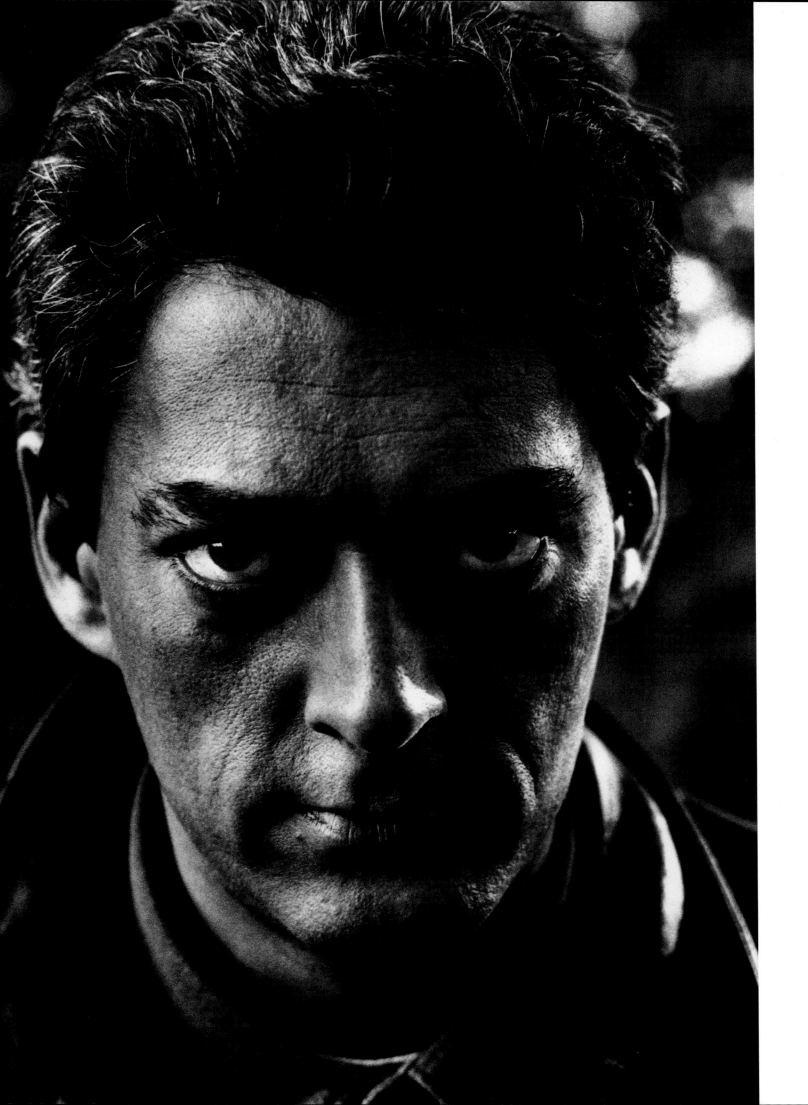

William Cooper 1990

Scenes from Provincial Life

'Don't you think you ought to come
away from the window, darling?'

'Why?'

'You've got nothing on.'

'All the better ...' Out of respect for
her delicacy I closed the window with
a bang that drowned the end of
my remark.

She was smiling at me. I went over and
stood beside her. She looked appealing,
resting on one elbow, with her dark
hair sweeping over her smooth naked
shoulder. I looked down on the top
of her head.

Suddenly she blew.
'Wonderful Albert,' she said.

I may say that my name is not Albert.
It is Joe. Joe Lunn.

Myrtle looked up at me in sly inquiry.

I suppose I grinned.

After a while she paused. 'Men *are* lucky,'
she said, in a deep thoughtful tone.
I said nothing: I thought it was no time
for philosophical observations.
I stared at the wall opposite.

Finally she stopped.
'Well?'
I looked down just in time to catch
her subsiding with a shocked expression
on her face.

'Now,' I said, 'you'll have to wait
again for your tea.'

'Ah ...' Myrtle gave a heavy, complacent
sigh. Her eyes were closed.

In due course we had our tea.

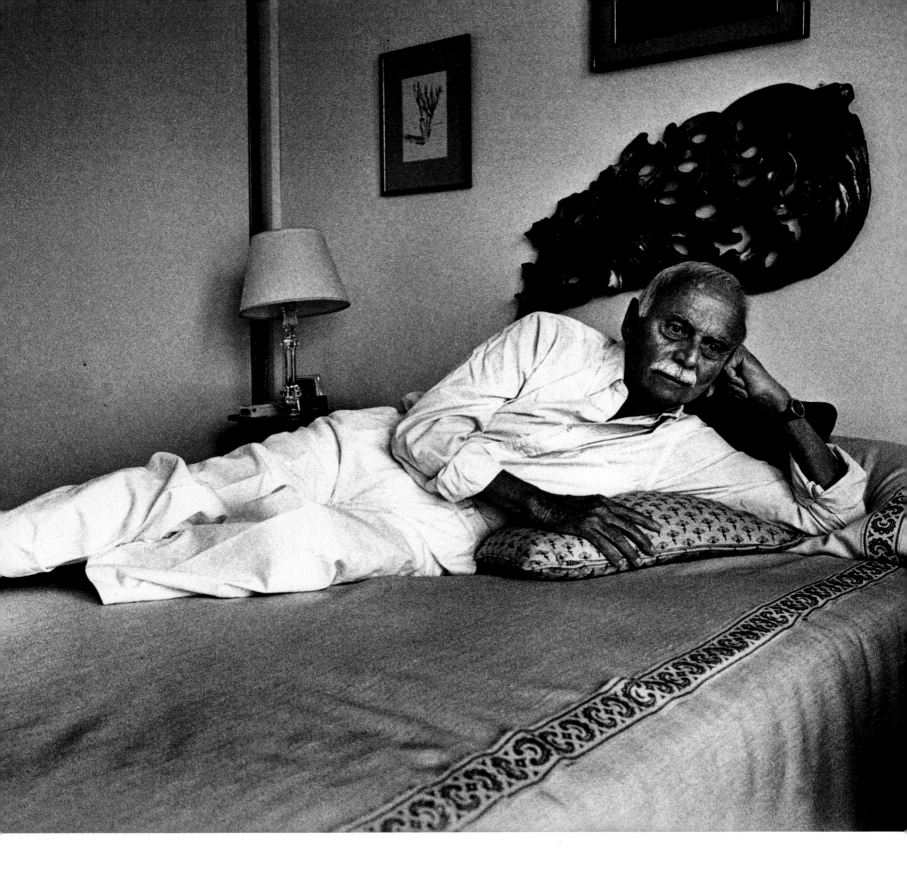

The Night Manager

He was a compact man but tentative,
with a smile of apologetic self-protection.
Even his Englishness was a well-kept secret.
He was nimble and in his prime of life.
If you were a sailor you might have spotted
him for another, recognised the deliberate
economy of his movements, the caged
placing of the feet, one hand always for
the boat. He had trim curled hair and
a pugilist's thick brow. The pallor of his
eyes caught you by surprise. You expected
more challenge from him, heavier shadows.

And this mildness of manner within
a fighter's frame gave him a troubling
intensity. You would never during your
stay in the hotel confuse him with anybody
else: not with Herr Strippli, the creamy-
haired front-of-house manager, not with
one of Herr Meister's superior young
Germans who strode through the place like
gods on their way to stardom somewhere
else. As a hotelier Jonathan was complete.
You did not wonder who his parents were
or whether he listened to music or kept
a wife and children or a dog. His gaze
as he watched the door was steady
as a marksman's. He wore a carnation.
At night he always did.

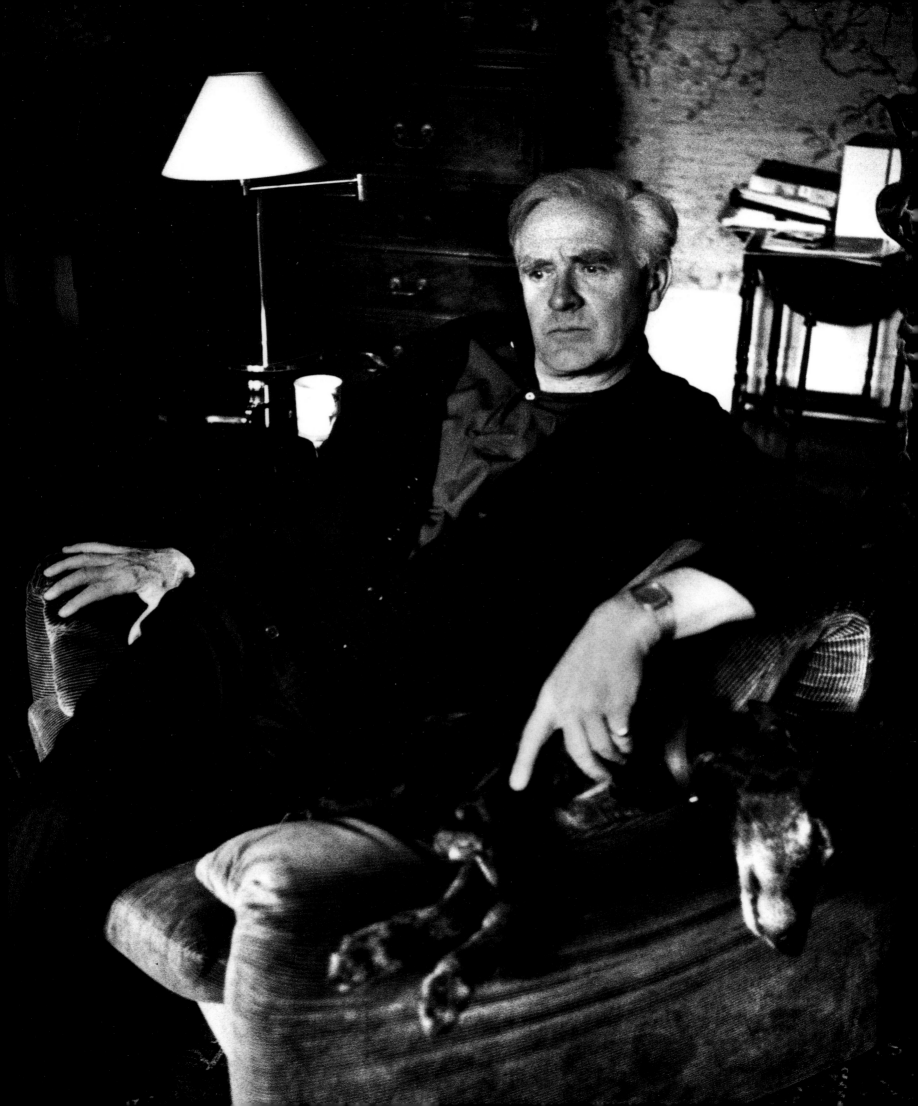

Barry Unsworth 1992

Sacred Hunger

Paris freighted the spoon with rice, then
put it back down on the plate again: he
saw now that the spoon was too big. He
took some of the moist and sticky rice
between his thumb and first two fingers
and extended this towards the man. He
was aware of the silence among the people
looking on – some of the women slaves
had joined the circle of seamen. There was
a ring round him, cutting off the air. The
stench of captivity came to him, from the
man before him, the spectators white and
black, the massed bodies of the slaves
under the awning.

'Eat,' he said. 'I want you to eat.' He could
read no expression on the broad, flat-boned
face, unless the approach of death can be
an expression. The eyes were fixed on the
strip of plank betwen his long and narrow
feet. The mouth hung open, a spongy
ellipse, allowing the pale loll of the tongue
to show within it. As Paris crouched there,
holding out in his fingers the sticky ball
of rice, he knew that he was alone with
this man, that the two of them were quite
alone. The pale sky had clutched at them,
gathered them into privacy, into some
area of seclusion. He did not know whose
was the greater arrogance, his or this
dying man's.

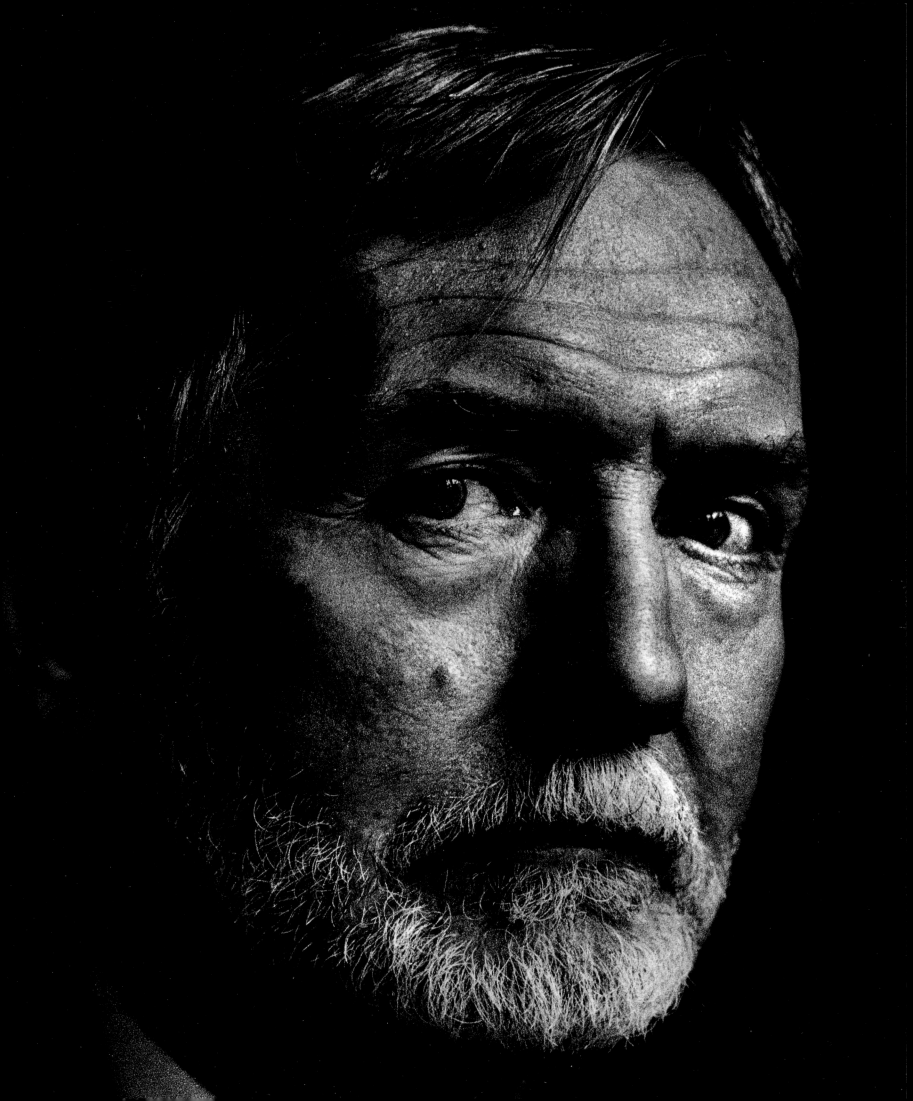

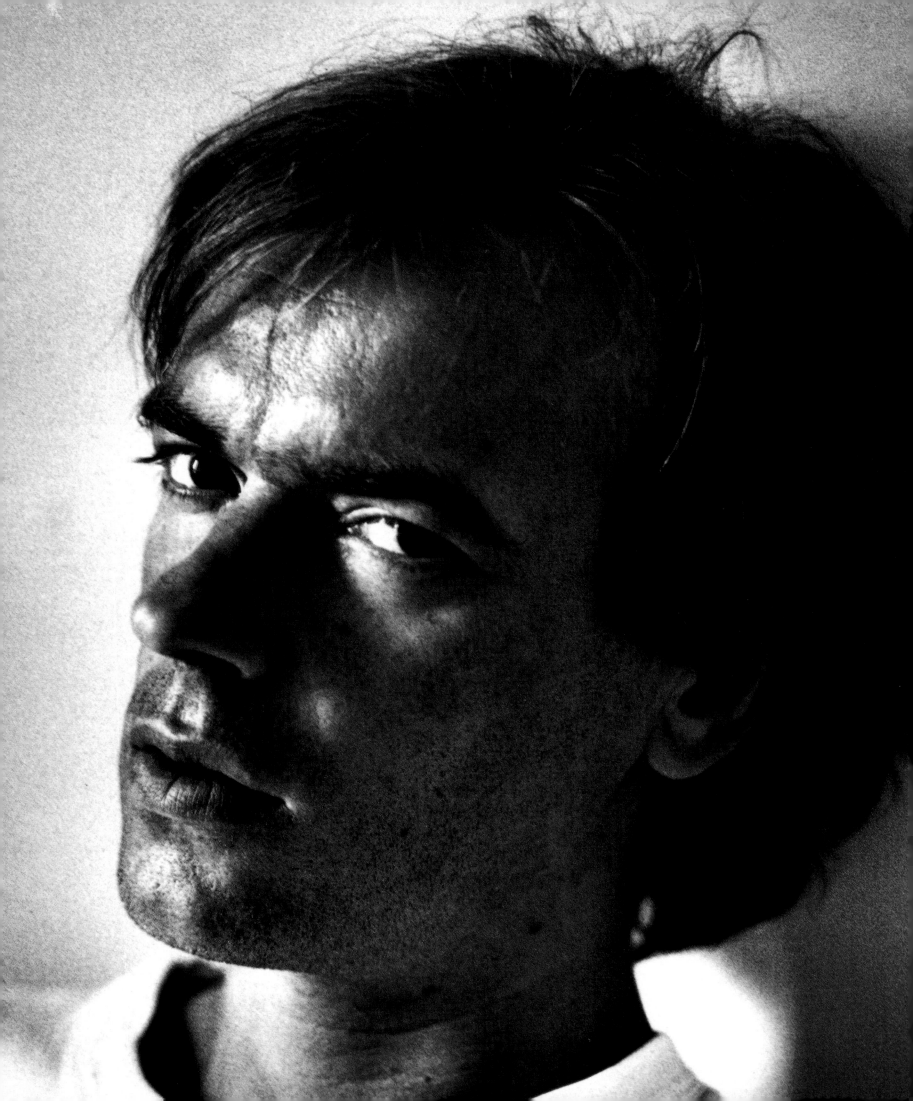

Martin Amis 1989

London Fields

But we mustn't go too far back, must we,
we mustn't go too far back in anybody's
life. Particularly when they're poor.
Because if we do, if we go too far back –
and this would be a journey made in
a terrible bus, with terrible smells and
terrible noises, with terrible waits and
terrible jolts, a journey made in terrible
weather for terrible reasons and for terrible
purposes, in terrible cold or terrible heat,
with terrible stops for terrible snacks,
down terrible roads to a terrible room –
then nobody is to blame for anything,
and nothing matters, and everything
is allowed.

Seamus Heaney 1988

Lightenings, from Seeing Things

Sink every impulse like a bolt. Secure
The bastion of sensation. Do not waver
Into language. Do not waver in it.

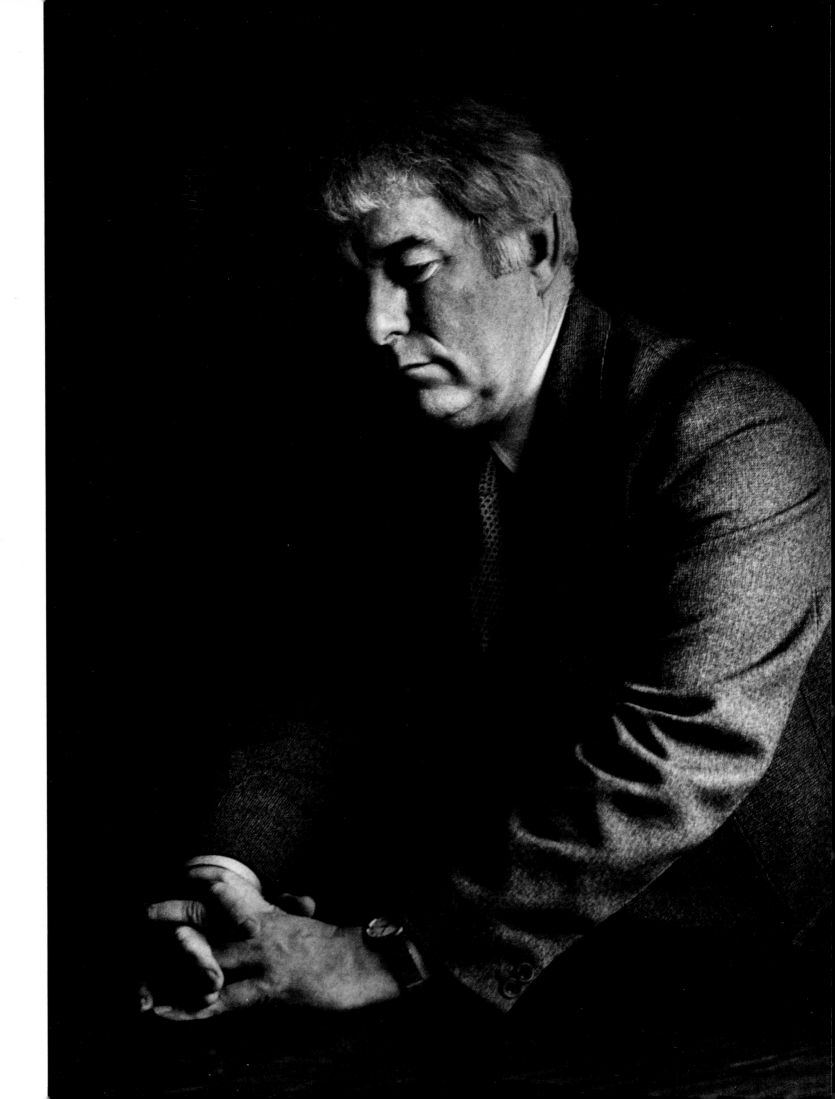

John Irving 1989

Mr Garg's Girl

Deepa had taken the night train to Bombay; she'd traveled from somewhere in Gujarat – from wherever the Great Blue Nile was playing. She'd arranged to bring the runaway child prostitute to Dr Daruwalla's office at the Hospital for Crippled Children, intending to shepherd the girl through her examination – it was the child's first doctor's visit. Deepa didn't expect there would be anything wrong; she planned to take the girl back to the Great Blue Nile with her. It was true that the child had run away from a brothel, but – according to Mr Garg – she'd managed to run away when she was still a virgin. Dr Daruwalla didn't think so.

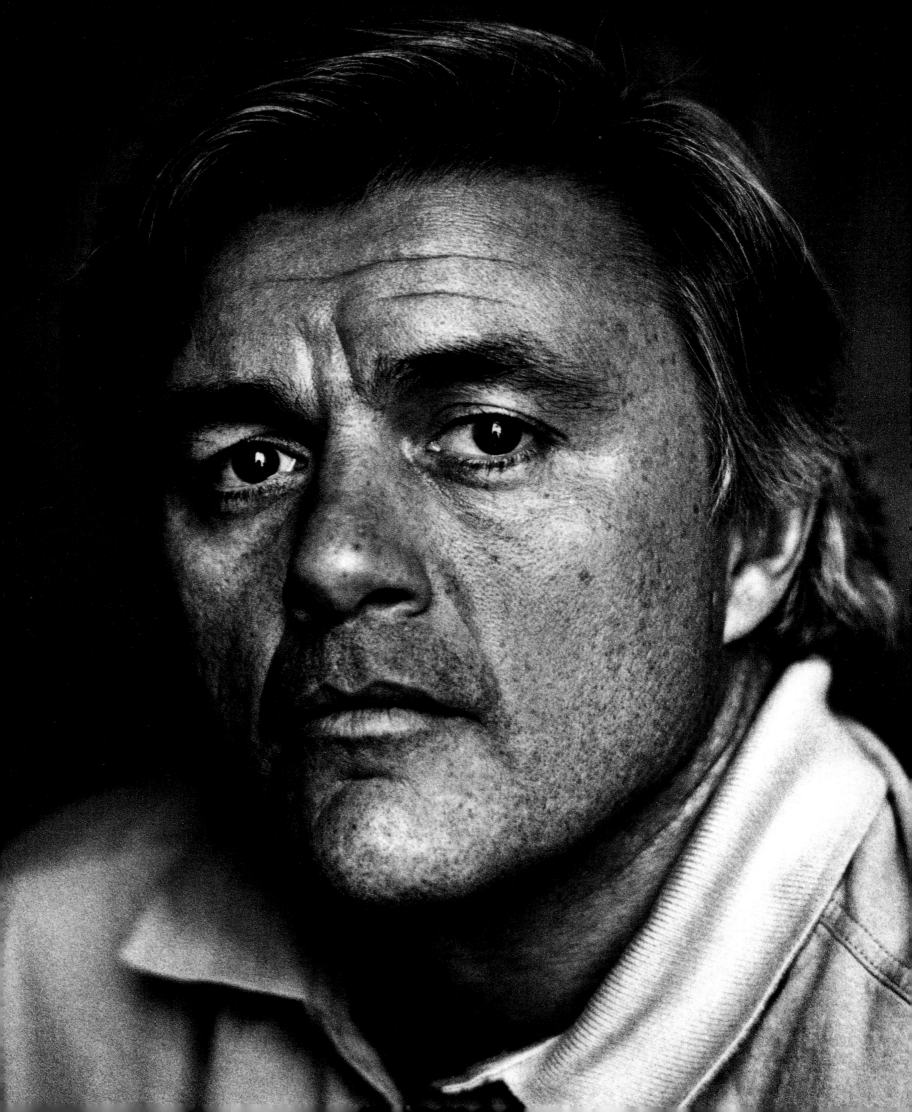

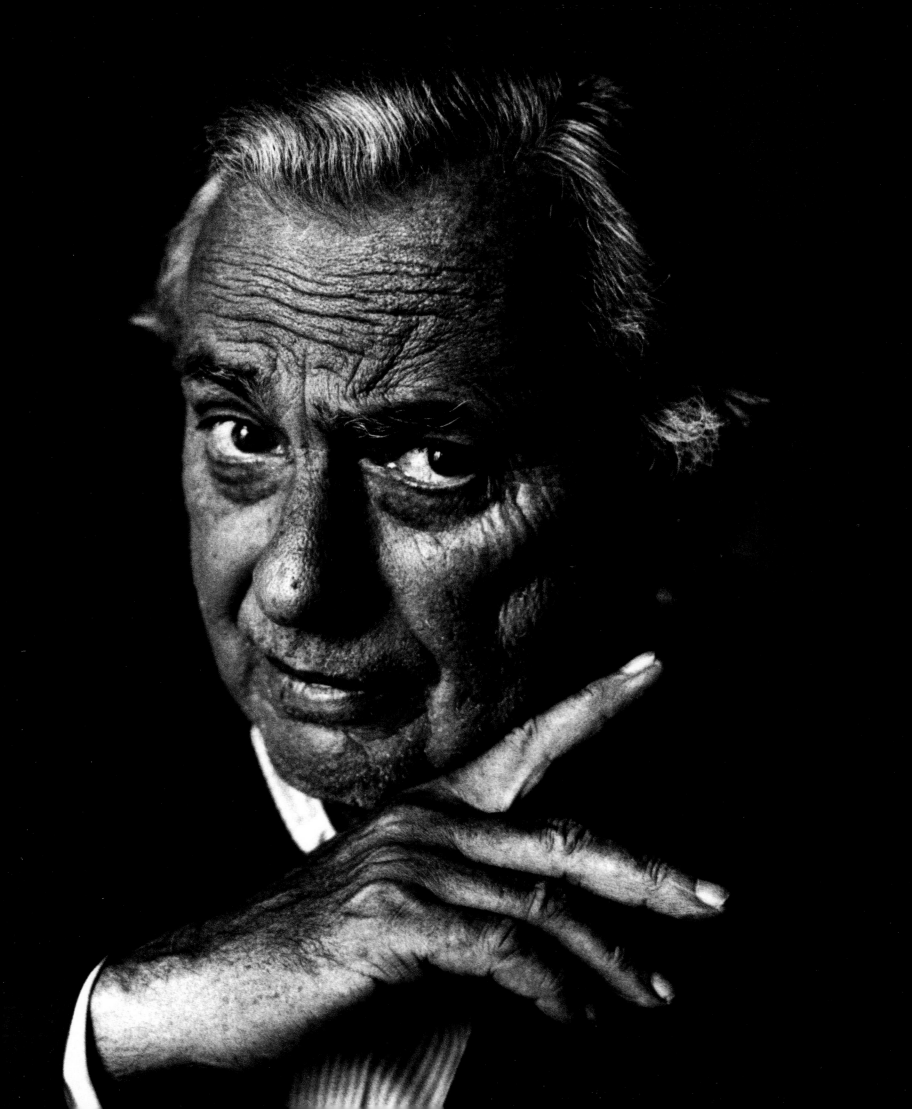

Gore Vidal 1989

Duluth

Duluth! Tricia taps, love it or loathe it,
you can never leave it or lose it because no
matter how blunt with insectivorous time
your mandibles become those myriad eggs
that you cannot help but lay cannot help
but hatch new vermiforous and myriapodal
generations, forever lively in *this* present
tense where you – all of you – are now
at large, even though, simultaneously,
you are elsewhere, too, rooted in that
centripetal darkness where all this was,
and where all this will be, once the bright
inflorescence that is, or – now for that
terminal shift, Tricia; press the lever! – *was*
present-day human Duluth has come to its
predestined articulated and paginated end.
Yes. *Duluth!* Loved. Loathed. Left. Lost.

Eugene Ionesco 1986

Journal en miettes

J'AI A PEU PRES l'impression qu'en moi se
déroulent des évènements, qu'en moi des
choses, des passions s'agitent, s'opposent;
que je me regarde et que je vois le combat
de ces forces contraires et que, tantôt
l'une, tantôt l'autre prend le dessus; une
mêlée, un champ mental de batailles et que
le vrai moi est ce 'je' qui regarde le 'moi'
des évènements et des conflits. Je ne suis
pas ces passions, semble-t-il, je suis celui
qui voit, regarde, commente, considère.
Je suis aussi celui qui, ardemment, désire
un autre moi.

I have the impression that events take
place in me, that in me things and passions
rage and conflict; that I watch myself and
see the fight of these hostile forces and
that first one, and then the other, has the
upper hand; a fight, a mental battleground
and that the real me is this 'I' who watches
the 'me' of events and conflicts. I am not
these passions, it seems, I am he who sees,
watches, comments, considers. I am also
he who, ardently, wants another me.

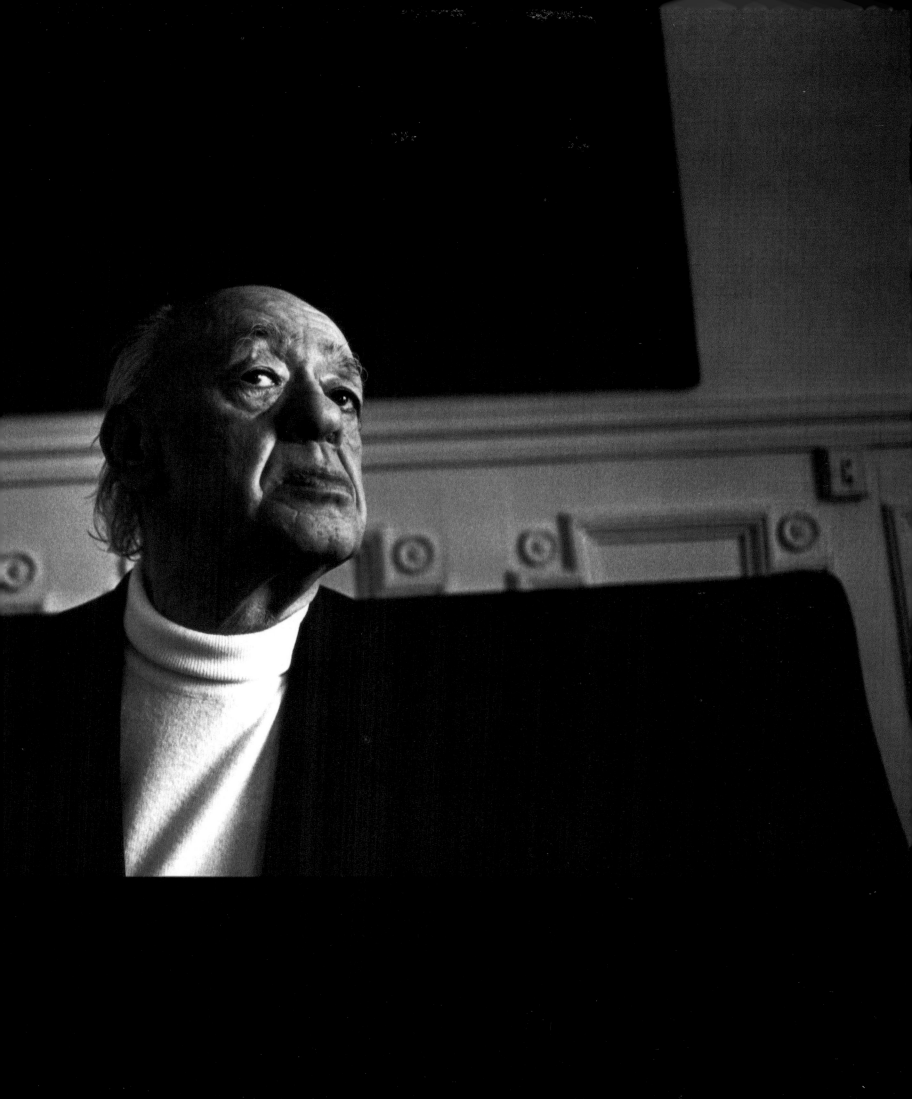

Camille Paglia 1992

Sexual Personae: Art and Decadence from Nefertiti to Emily Dickinson

Everything is melting in nature. We think we see objects, but our eyes are slow and partial. Nature is blooming and withering in long puffy respirations, rising and falling in oceanic wave-motion. A mind that opened itself fully to nature without sentimental preconception would be glutted by nature's coarse materialism, its relentless superfluity. An apple tree laden with fruit: how peaceful, how picturesque. But remove the rosy filter of humanism from our gaze and look again. See nature spuming and frothing, its mad spermatic bubbles endlessly spilling out and smashing in that inhuman round of waste, rot and carnage. From the jammed glassy cells of sea roe to the feathery spores poured into the air from bursting green pods, nature is a festering hornet's nest of aggression and overkill.

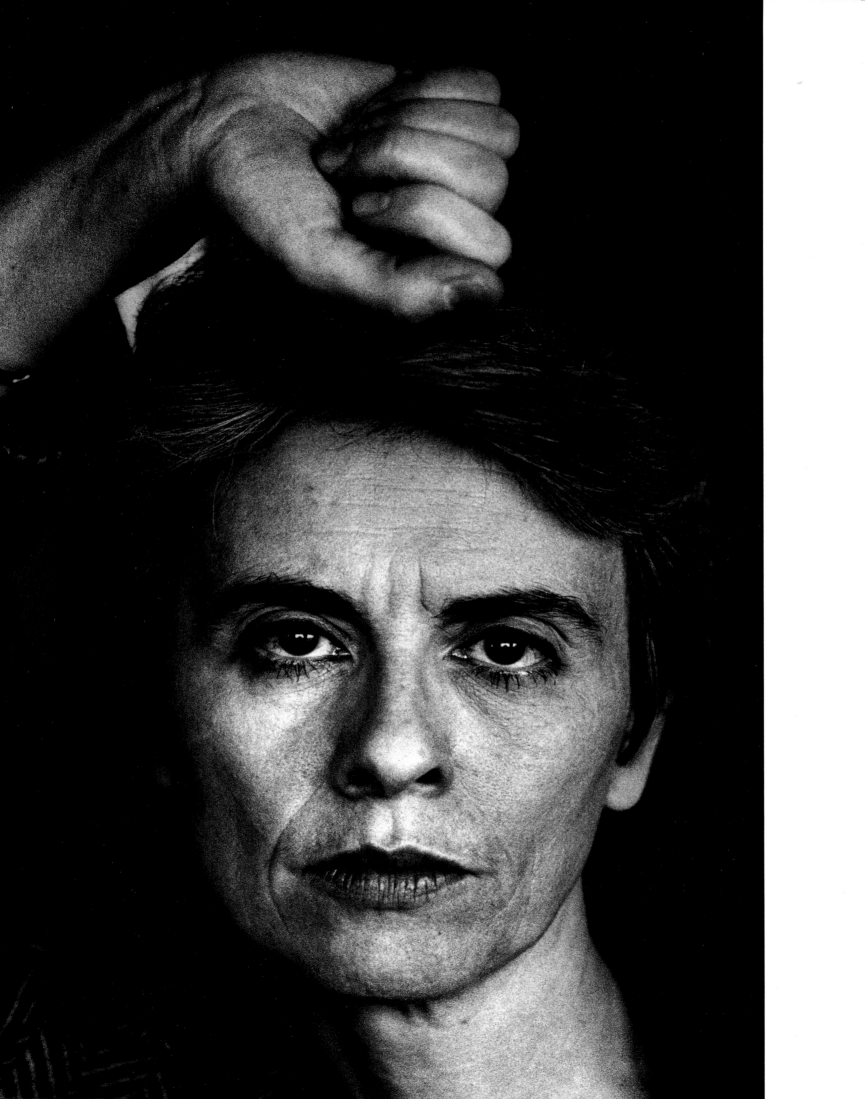

In the Mood

I lived in a different country once.
Nothing there was the same as now.
All that happened then, if it happened
here, would be strange and fresh.

Everything was sharper. Cigarette smoke
had a pungency it has since lost. Even
stale beer smelled full-bodied and good.
Girls' breasts were whiter. Like alabaster,
we said, though none of us knew what
alabaster was in that long-ago place.
The air was as crisp as apples, and
all the sad songs were sweeter, then.

Youth was our visa to this country.
Although we were only visitors, yet it had
no other inhabitants while we were there,
or none that we recognised. There were
those whose shadows were thrown across
our path sometimes, but they were to
us as aborigines must have been to the
old settlers. Alice in Wonderland dodoes
waddled self-importantly about with
bunches of keys on chains, membrane-
thin pterodactyls flapped the ledger-dust
off their wings, troglodytes drew academic
gowns around themselves like shrouds,
fossils propped up on the benches of
bowling greens followed us with their
petrified stare. They were nothing to do
with what we were. These were our years
and this was our green land. It is all far
off from what we have become.

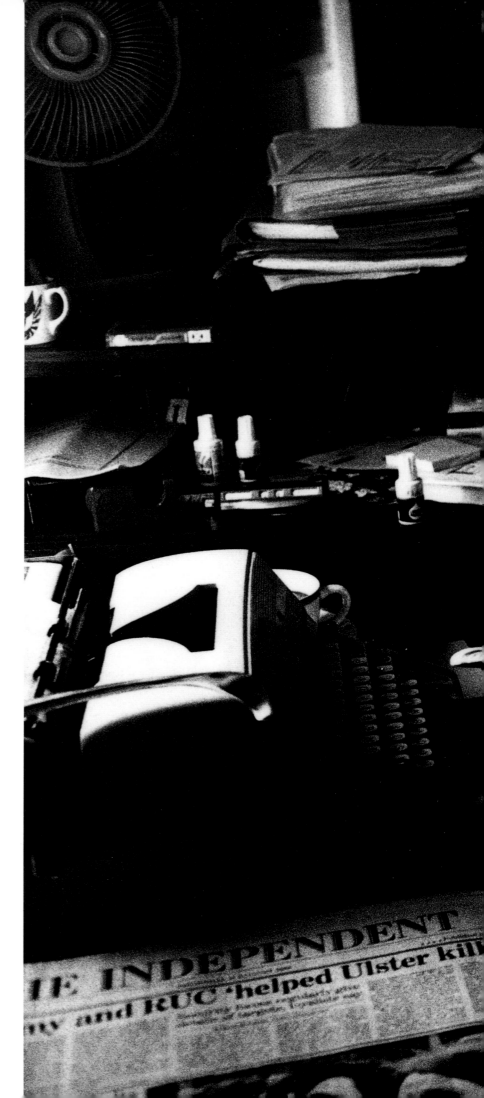

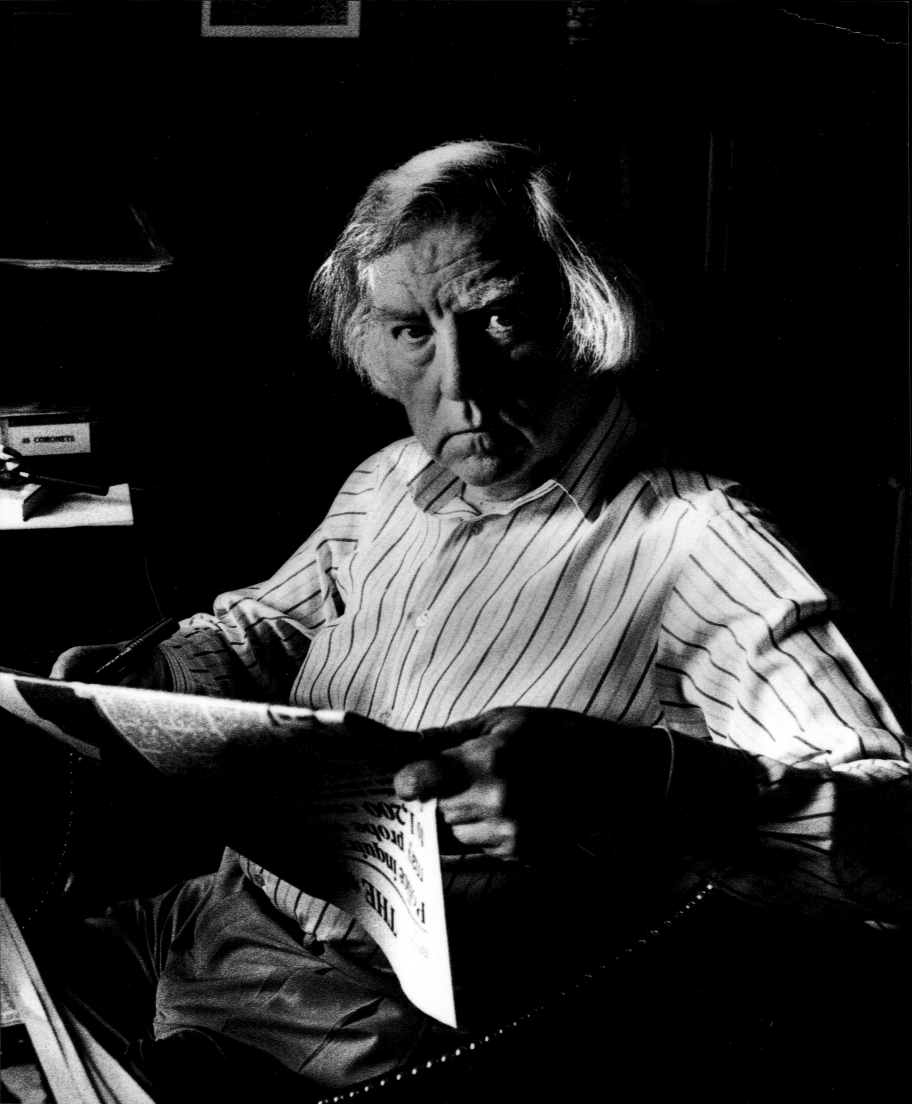

Hilary Mantel 1992

Fludd

The parlour in the convent was both stuffy
and cold, and smelled mysteriously of
congealed gravy. It was little used; Fludd
sat by the empty fireplace, on a hard chair,
waiting for Mother Purpit. Under his feet
was dark, shiny linoleum in a pattern of
parquet squares, relieved by a red fireside
rug. Over the mantelpiece, Christ hung
in a heavy gilt frame, thin yellow tongues
of light streaming from his head. His
ribcage was open, nearly split by the Roman
spear, and with a pallid, pointed figure he
indicated his exposed and perfectly heart-
shaped heart.

Against the far wall was a big, heavy chest
with a stout-looking iron lock; oak, it might
be, but varnished with a heavy hand over
the years, so that its surface seemed sticky
and repelled the light. I wonder what is in
that chest, thought Fludd. Nuns' requisites;
now what would they be?

Irwin Shaw 1977

Five Decades

Why does a man spend fifty years of his
life in an occupation that is often painful?
I once told a class I was teaching that
writing is an intellectual contact sport,
similar in some respects to football. The
effort required can be exhausting, the
goal unreached, and you are hurt on almost
every play, but that doesn't deprive a man
or boy from getting peculiar pleasures
from the game.

In a preface to an earlier collection
I described some of these pleasures.
Among them, I wrote, there is the reward
of the storyteller, sitting cross-legged in
the bazaar, filling the need of humanity
in the humdrum course of the ordinary
day for magic and distant wonders, for
disguised moralising that will set everyday
transactions into larger perspectives,
for the compression of great matters
into digestable portions, for the shaping
of mysteries into sharply edged and
comprehensive symbols.

Then there is the private and exquisite
reward of escaping from the laws of
consistency. Today you are sad and you
tell a sad story. Tomorrow you are happy
and your tale is a joyful one. You remember
a woman whom you loved whole-heartedly
and you celebrate her memory. You suffer
from the wound of a woman who treated
you badly and you denigrate womanhood.
A saint has touched you and you are
a priest. God has neglected you and you
preach atheism.

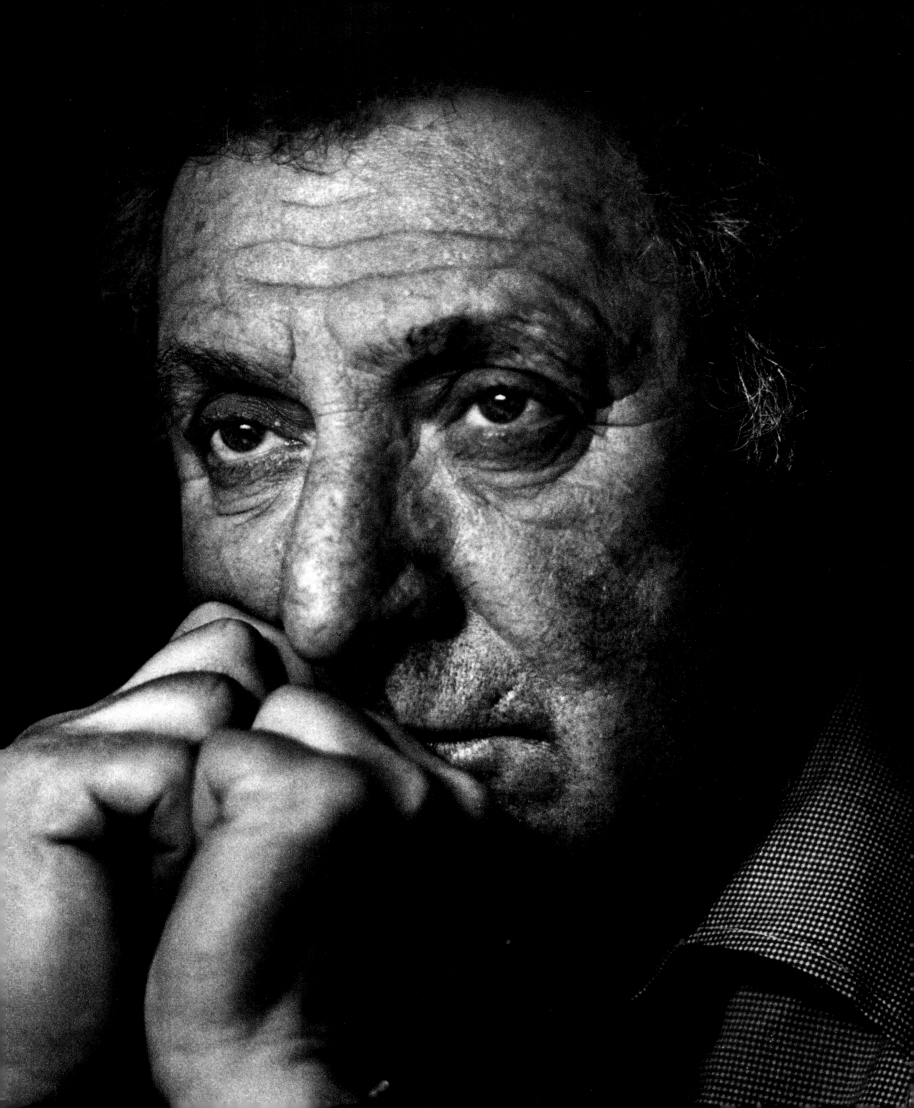

Edna O'Brien 1988

On the Bone

When dogs bark
I think of you
And dogs bark
The world over
Even in ochre-veined Mexico
Where the women scrape the cacti
And offer them
Like Manna
With heads bowed.
On those nights of the vehement dogs
I think of you –
Oh Mother
Is there still such a long way
To go
Even though the end has been?
Ours was a lonely wine
A lonely trail,
Without dalliance
Without men-folk.

Duologues and Dialogues
Much the same,
Climbing the next bit of missing stairs,
Like a gate hasp
Or a paw.
Oh Mother without mercy,
I am back now
I am here to stay.
Ours was a lonely wine
A lonely trail
I would make it again
For the sake of the song
For the sake of the rose.
Let us fold it together.
Petal upon petal
Glorious
Ancestral
Menstrual
Rose
Made red
From
The pool
Of our
Being.

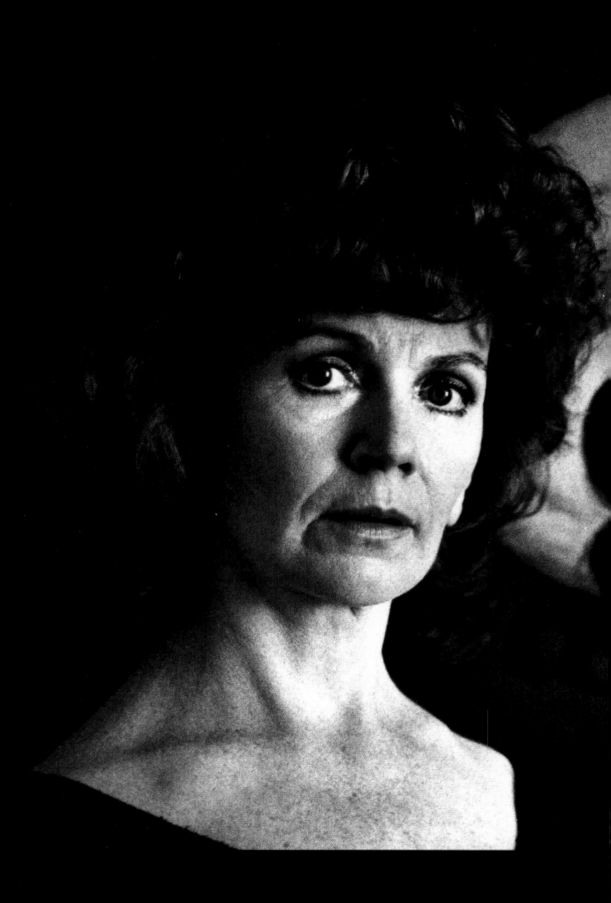

He had falle
t ages on her,
introduced her
t thought had
ly I had m
Teddy, it wi
have borrow
l we, we
our she's
lasl

in love when
when Teddy
his fiancé's.
been it's too
her first, wel
have happe
i she would
made for e
forever. Had

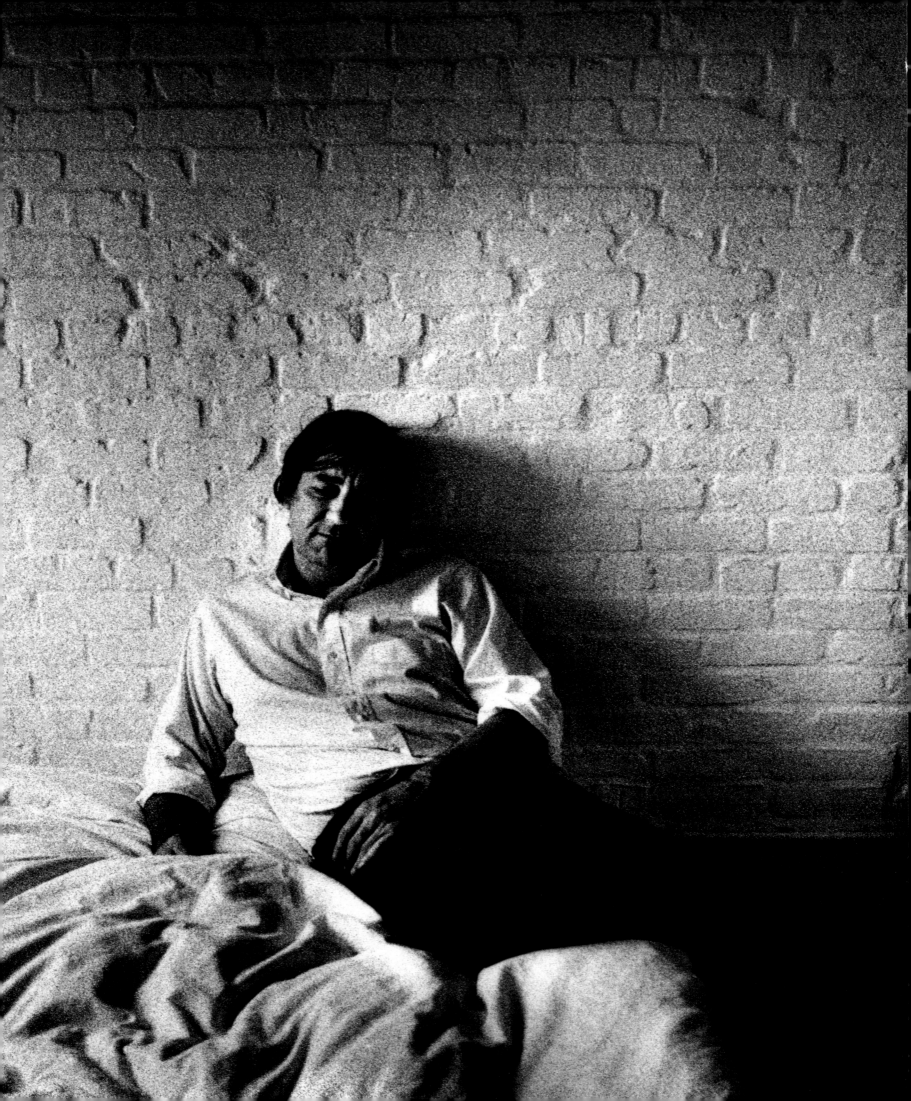

Bibliographic acknowledgements

Martin Amis
Page 134
From *London Fields,* © Martin Amis 1989, published by Jonathan Cape in 1989 and Crown Publishing Group in 1990. Reprinted by permission of the author, Random House UK Ltd and Peters Fraser & Dunlop.

Maya Angelou
Page 34
From 'I Shall Not Be Moved' in *I Shall Not Be Moved,* © Maya Angelou 1990, published by Virago Press, London, & Random House, New York in 1990. Reprinted by permission of the author, Virago Press, and Random House, Inc.

Simon Armitage
Page 36
'Strike Two. My Mind Works' from *Book of Matches,* © Simon Armitage 1993, published by Faber in 1993. Reprinted by permission of the author and Faber & Faber Ltd.

Margaret Atwood
Page 26
'This is a Photograph of Me', © Margaret Atwood 1966, from *Poems 1965-1975,* published by Virago Press, London, in 1991, *The Circle Game, Selected Poems I,* © Margaret Atwood 1976, published by Houghton Mifflin, New York, and *Selected Poems,* © Margaret Atwood 1990, published by Oxford University Press, Canada. Reprinted by permission of the author, Virago Press and the Phoebe Larmore Literary Agency.

Paul Auster
Page 126
From 'The Locked Room' in *The New York Trilogy,* © Paul Auster 1985, 1986, 1987, published by Faber/Penguin USA. Reprinted by permission of the author, Faber & Faber and the Carol Mann Agency.

Julian Barnes
Page 60
From *Flaubert's Parrot,* © Julian Barnes 1984, published by Jonathan Cape/Knopf in 1984. Reprinted by permission of the author, Random House UK Ltd, and Peters Fraser & Dunlop.

Saul Bellow
Page 118
From 'Something To Remember Me By', © 1990 by Saul Bellow, first published in Esquire magazine, from *Something To Remember Me By,* published by Viking Penguin in 1991/Penguin Books in 1993. Reprinted by permission of the author, Penguin Books Ltd and Viking Penguin, a division of Penguin Books USA Inc.

Jorge Luis Borges
Page 78
From 'Borges and I' in *A Personal Anthology,* translated by Anthony Kerrigan, published by Jonathan Cape in 1968 and in the USA by Grove Press. Reprinted by permission of the Estate of Jorge Luis Borges and Emece Editores, S.A.

Malcolm Bradbury
Page 86
From *The History Man,* published by Secker & Warburg in 1975 and Penguin USA in 1985. Reprinted by permission of the author and Reed Consumer Books.

Anthony Burgess
Page 42
From *Earthly Powers,* © Estate of Anthony Burgess 1980, published by Hutchinson/Simon & Schuster in 1980. Reprinted by permission of the author and Artellus Limited.

John le Carré
Page 130
From *The Night Manager,* © David Cornwell 1993, published by Hodder & Stoughton/Alfred Knopf in 1993. Reprinted by permission of the author, Hodder & Stoughton Ltd and David Higham Associates.

Angela Carter
Page 112
From *Expletives Deleted,* © Angela Carter 1992, published by Chatto & Windus/Vintage in 1992. Reprinted by permission of the author's literary executor, and Rogers, Coleridge & White.

Bruce Chatwin
Page 94
From *In Patagonia,* © 1977 by Bruce Chatwin, Sections 73, 75 and 85 © by Monica Barnett, published by Jonathan Cape/Simon & Schuster in 1977. Reprinted by permission of the author's literary executor, Random House UK Ltd and Simon & Schuster, Inc.

Tom Clancy
Page 30
From a speech made at Villanova University in 1990 during the graduation ceremony at which he received the Honorary Degree of Doctor of Laws. Reprinted by permission of the author.

Isabel Colegate
Page 122
From *The Shooting Party,* published by Penguin Books in 1980 and Viking Penguin in 1991. Reprinted by permission of the author and Peters Fraser & Dunlop.

David Cook
Page 46
From *Winter Doves,* © David Cook 1979, published by Secker & Warburg in 1979 and Overlook Press in 1985. Reprinted by permission of the author and Reed Consumer Books.

William Cooper
Page 128
From *Scenes from Provincial Life,* published by Macmillan in 1982. Reprinted by permission of the author, Macmillan London Ltd and Aitken, Stone & Wylie.

Robertson Davies
Page 24
From a speech delivered to the Royal Society of Canada in 1973. Reprinted by permission of the author.

J P Donleavy
Page 70
From *The Beastly Beatitudes of Balthazar B,* © J P Donleavy 1969, published by Penguin Books in 1969 and Grove-Atlantic in 1988. Reprinted by permission of the author.

Richard Ford
Page 120
From *Wildlife,* © Richard Ford 1990, published by Harvill/Atlantic Monthly/Little Brown, Canada in 1990. Reprinted by permission of the author, Rogers Coleridge & White, and Grove/Atlantic, Inc.

Carlos Fuentes
Page 32
From *Terra Nostra,* published by Farrar Straus & Giroux in 1976 and Secker & Warburg in 1977. Reprinted by permission of the author.

William Golding
Page 72
From *A Moving Target,* © William Golding 1982, published by Faber/FS&G. Reprinted by permission of Faber & Faber and Farrar, Straus & Giroux, Inc.

Alasdair Gray
Page 114
'Economy', © Alasdair Gray 1994. Reprinted by permission of the author.

David Grossman
Page 90
From *See Under Love,* © David Grossman 1989, Ena translation © Betsy Rosenberg 1989, published by Jonathan Cape/Farrar, Straus & Giroux in 1989. Reprinted by permission of the author, Random House UK Ltd and Richard Scott Simon Ltd.

Helene Hanff
Page 50
From *84 Charing Cross Road,* published by Deutsch in 1971 and Penguin USA in 1990. Reprinted by permission of the author, André Deutsch and Flora Roberts Inc.

Josephine Hart
Page 96
From *Damage,* published by Chatto & Windus/Alfred Knopf in 1991. Reprinted by permission of the author, Random House UK Ltd, Ed Victor Ltd and Alfred A. Knopf, Inc.

Seamus Heaney
Page 136
From 'Lightenings, ii' in *Seeing Things,* © Seamus Heaney 1991, published by Faber/Farrar Straus & Giroux in 1991. Reprinted by permission of the author and Faber & Faber.

George V Higgins
Page 48
From *The Mandeville Talent,* © 1991 by George V Higgins, published by Holt/Deutsch in 1991. Reprinted by permission of the author, André Deutsch Ltd, and Henry Holt & Company Inc.

Eugene Ionesco
Page 142
From *Journal en miettes,* © Mercure de France 1973, published by Mercure de France in 1973. Reprinted by permission of the author and the publishers. This translation by Barry Winkleman used with the permission of Quartet Books, publishers of the official English translation, *Fragments of a Journal.*

John Irving
Page 138
From *A Son of The Circus,* published by Bloomsbury Publishing Ltd/Random House Inc. in 1994. Reprinted by permission of the author and publishers.

Kazuo Ishiguro
Page 106
From *The Remains of the Day,* © Kazuo Ishiguro 1989, published by Faber/Alfred Knopf. Reprinted by permission of the author, Faber & Faber Ltd, Rogers Coleridge & White, and Alfred A. Knopf, Inc.

P D James
Page 44
From *Devices and Desires,* © P D James 1989, published by Faber/Alfred Knopf. Reprinted by permission of the author, Faber & Faber, and Alfred A. Knopf, Inc.

William Kennedy
Page 82
From *Ironweed,* © 1979, 1981, 1983 by William Kennedy, published by Penguin in the UK in 1984. Reprinted by permission of the author, the Tessa Sayle Agency and Viking Penguin, a division of Penguin Books USA Inc.

Francis King
Page 62
From 'His Everlasting Mansion' in *One is a Wanderer,* published by Hutchinson in 1985. Reprinted by permission of the author and A M Heath & Co Ltd.

Acknowledgements

The Editor of The Sunday Times,
Andrew Neil, and Michael Cranmer,
Aidan Sullivan and Ray Wells,
my Picture Editors during the
preparation of this book.

Penny Perrick, Nigel Horne,
John Walsh, Harry Ritchie,
Norman Lebrecht, Jane Krivine,
David Driver, Peter Baistow,
Ros Newcomen, Edwin Taylor,
Geraldine Sharpe-Newton,
Robert Ducas, David Lodge,
Richard Ford, Cindy Black,
Peter Florence, Peter Crookston,
June Stanier, Sue Adler,
Arnold Kransdorff, Jacky Bennett
and Roberto Parrales for help and
advice that never flagged.

Michael Roffey and Alison Rogers
of *The Sunday Times* picture library.

Judith McNally, Vanessa Friedman
and Pamela McCarthy in New York;
Carina Pons at Agencia Literaria
Carmen Balcells in Barcelona;
Maryvonne le Doucen at Editions
Gallimard in Paris and
Connie Hallam in Banbury, England,
for their professional helping hands.

Michael Spry, who printed the
photographs, and his colleagues;
Keith Bradley, Steve Walsh
and Shelly Collins of Downtown
Darkrooms Ltd, London.

Quentin Newark, James Phelan
and Glenn Howard of Atelier,
who designed the book, and
Jane Heath, who did everything
they asked.

Will Atkinson, David Blow,
David Banks, Simon Whiteside,
Emily Fischer and Michael Paine of
Waterstone's, Hampstead, London.

Suzannah Clapp, literary executor
to Bruce Chatwin and Angela Carter;
Marian Shaw, literary executor to
Irwin Shaw, and John Bodley,
Sir William Golding's editor at Faber.

And, in particular, my brother
Barry Winkleman; Tom Rosenthal
of André Deutsch and
Norman Mailer, who wrote the first
grown-up book I ever read.